5-MINUTE SKETCHING
PEOPLE

A FIREFLY BOOK

Published by Firefly Books Ltd. 2016

First printing

Publisher Cataloging-in-Publication Data (U.S.)

Names: Scully, Pete, author.
Title: People : super-quick techniques for amazing drawings / Pete Scully.
Description: Richmond Hill, Ontario, Canada : Firefly Books, 2016.
 | Series: 5-minute sketching | Includes index. | Summary: "This book comprises exercises and tips to help the reader improve their sketching speed, and capture everyday people on paper before they can get restless. This book focuses on sketching portraits of people" -- Provided by publisher.
Identifiers: ISBN 978-1-77085-758-2 (paperback)
Subjects: LCSH: Portrait drawing -- Technique.
Classification: LCC NC773.S385 |DDC 743.42 – dc23

Library and Archives Canada Cataloguing in Publication

Scully, Pete, author
 People : super-quick techniques for amazing drawings
/ Pete Scully.
(5-minute sketching)
Includes index.
ISBN 978-1-77085-758-2 (paperback)
 1. Figure drawing--Technique. 2. Portrait drawing--
Technique. I. Title.
NC765.S38 2016 743.4 C2016-902081-9

Published in the United States by
Firefly Books (U.S.) Inc.
P.O. Box 1338, Ellicott Station
Buffalo, New York 14205

Published in Canada by
Firefly Books Ltd.
50 Staples Avenue, Unit 1
Richmond Hill, Ontario L4B 0A7

Printed in China

Conceived, designed, and produced
by RotoVision
4th Floor Ovest House
58 West Street
Brighton,BN1 2RA
England

Publisher: Mark Searle
Editorial Director: Isheeta Mustafi
Commissioning Editor: Alison Morris
Editor: Nick Jones
Junior Editor: Abbie Sharman
Design Concept & Cover Design: Michelle Rowlandson
Page Design: JC Lanaway

Image credits

Cover and opposite: Pete Scully

5-MINUTE SKETCHING
PEOPLE

Super-quick Techniques for Amazing Drawings

PETE SCULLY

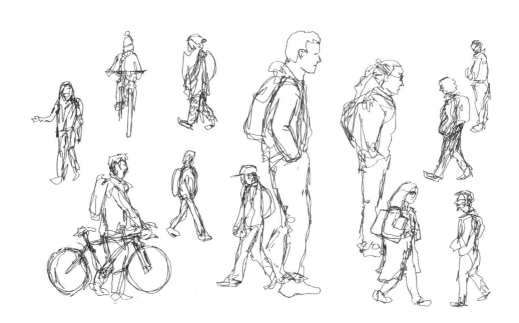

FIREFLY BOOKS

Contents

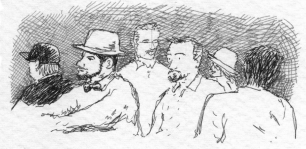

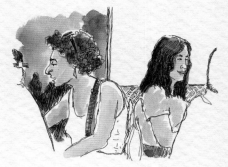

Chapter 3

TIME-SAVING TECHNIQUES 72

Chapter 4

SPEEDY SUPPLIES 102

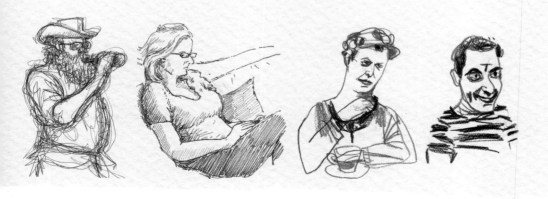

Introduction

TIME IS THE MOST PRECIOUS THING WE HAVE. We're always busy; there's no time to do the things we want, no time to stop and take a look at the world around us. No time to sketch. Well, I can tell you from experience, there is time to sketch. It might only be five minutes at the end of lunch, or five minutes after taking the kids to school. Five minutes while waiting for your food at a restaurant, or five minutes while watching a game of soccer. Five minutes at the local market, or five minutes spent waiting for the bus (or more, if you live in certain cities). In those five minutes, with a pen or a pencil, or even some paints, or maybe just your tablet, you can sketch, just a little here, a little there, until eventually you find yourself sketching in all sorts of spare moments. They don't need to be finished masterpieces, but they are all personal to you, and with all those small bits of practice you might just see your work grow in confidence.

I always used to say, "I don't like drawing people." I am an urban sketcher who likes to draw buildings, bridges, fire hydrants — inanimate objects. People ... well, they tend to move around. They can't sit still. They walk too fast to draw. They are all different shapes and sizes. Sometimes they are full of energy, sometimes they are tired, sometimes happy, and sometimes angry. People like to talk, to each other or maybe to you. People will react to you drawing them. A fire hydrant never told me I made it look old. A parked car never asked me to slim it down by 20 pounds.

And yet people are everywhere, and their untold individualities really do make them interesting to draw, once you start looking. The act of sketching need not be a stealthy act; rather it can be an icebreaker. Ask someone if you can sketch them and you may have a conversation, learn about their life, all of which might enter the sketch. You can often tell a happy and relaxed sketch, and though it may not be an exact perfect likeness, you are still capturing how you see the essence of a person. Sketching helps us engage

with our environments; by sketching people, we may start to connect with them a little more easily. A fire hydrant never bought me a beer after I sketched it.

When you only have five minutes to sketch, those quick-moving, talkative people frequently make the perfect subjects. Five minutes is often more than enough to sketch someone, whether you are studying their overall shape, or capturing their smile, or the texture of their scarf. In this book, I hope to show you a few basics to get you started, and to help you along. The focus is mostly drawing from real life, direct observation — not necessarily in posed situations, such as life drawing classes or in the studio with photo references. Quick, on-the-go sketching allows you to capture the immediacy of the world, and encourages you to push the boundaries of your skill set, whether you are a beginner or a seasoned sketcher.

We're all so busy, but not too busy to sketch. Five minutes is all you need.

Pete Scully

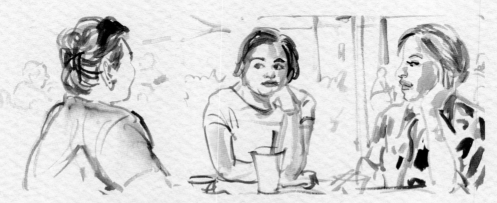

Above **Kumi Matsukawa, _Newton food center_, 2015.**

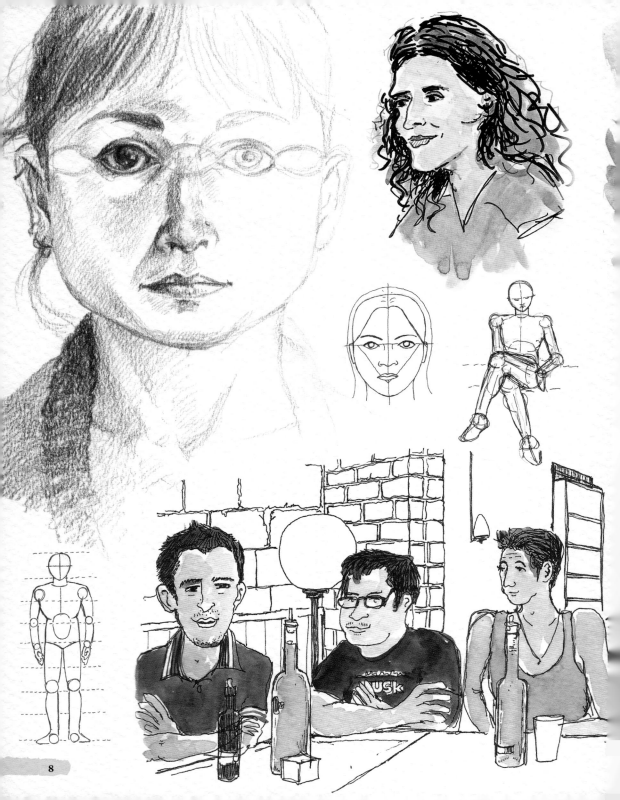

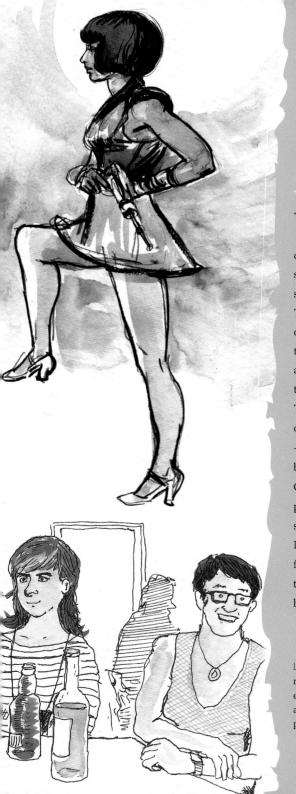

How to see

We know what people look like. We see them all the time. And yet, when we first start drawing people, a lot of the time we forget the simplest things. What shape are they? Where should the ears go? How long should the legs be? This can be doubly frustrating when we are actually observing the person in real life while we sketch them. Draw a building slightly out of proportion and you're forgiven; draw a person with their eyes too far apart and immediately it looks out of place. This is all part of the learning process, and the art of sketching is the act of teaching ourselves to see — not just to draw what our minds tell us should be, but to record what our eyes actually see. Observe how light reflects on the hair. Watch how people place their feet when they walk. Look at the shapes people make when they are in a group. Relying on your eyes alone isn't enough; practicing frequently is key to building up your skills, so that the next time you have five minutes to sketch, you'll have a whole toolbox of tricks to fall back on.

Left Sketching people from observation means knowing a few basics. These examples offer a study of faces, bodies, arms and legs, as well as casual seated poses over dinner.

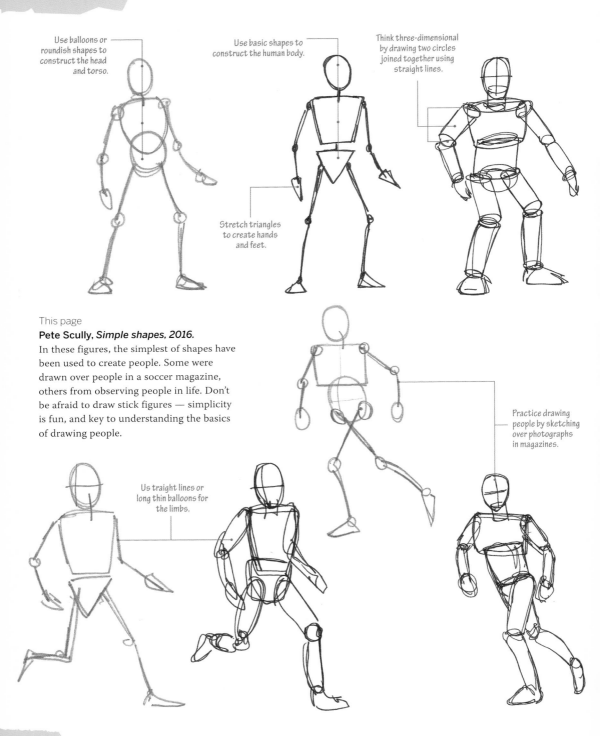

Use balloons or roundish shapes to construct the head and torso.

Use basic shapes to construct the human body.

Think three-dimensional by drawing two circles joined together using straight lines.

Stretch triangles to create hands and feet.

This page

Pete Scully, _Simple shapes, 2016._
In these figures, the simplest of shapes have been used to create people. Some were drawn over people in a soccer magazine, others from observing people in life. Don't be afraid to draw stick figures — simplicity is fun, and key to understanding the basics of drawing people.

Practice drawing people by sketching over photographs in magazines.

Us traight lines or long thin balloons for the limbs.

Outline simple shapes

For the beginner, any drawing can feel like a daunting task. One way to overcome the challenge of drawing is to break things down into simple shapes. By starting at the beginning, with circles, squares, triangles and oblongs, you are using tools you're probably already comfortable with.

Tips to get you started

1 **Practice basic shapes** On a piece of paper, draw a circle, a square, a triangle and a rectangle. Then try drawing a simple human form using just those basic shapes. Play with their size and structure — make the rectangle into a trapezoid for the torso, the circle into a more oval shape for the head and stretch the triangles for the hands and feet. Play around with these simple forms.

2 **Balloons** You might start by drawing the body as if made of balloons or roundish shapes — one for the head, a larger one for the upper torso, another connected to the lower torso. Then draw straight lines (or long, thin balloons) for the arms and legs. This can serve as a basic frame over which you can draw more detail.

3 **Cylinders** Once you start thinking more three-dimensionally, you might construct a body using cylinders. Practice the cylinder shape by drawing two circles and then joining them up with straight lines from the top and bottom. Cylindrical figures might look a little like artists' mannequins or the Tin Man from Oz, but this is just a starting block!

4 **Wires first** Another method is to start by drawing someone as a single line from head to foot, curving wherever their spine curves. Then add a small horizontal line about where the shoulders are. From there, use basic shapes to draw the head, upper torso and pelvis area, and then the arms and legs can be lines extending from the basic frame.

5 **Draw over photos** One way to practice looking for the basic shapes in the human body is to trace those shapes over photos in magazines. Use a thick marker and then practice redrawing those shapes in the same way on a separate piece of paper to get a feel for the proportions. It's not exactly drawing from life, but it helps you visualize people in simple geometric terms — plus it's fun!

Basic proportion: faces

When you draw a building, getting the windows slightly too far apart
or the door slightly too wide will not make a lot of difference overall — it still
looks like the building you are drawing. With people, particularly with faces,
small variations can radically alter their appearance, making them seem
unnatural, or at least not looking much like themselves. Here are a few
basics to keep in mind when making quick sketches of faces.

Tips to get you started

1 **Inverted egg** The simplest shape for the head is the "inverted egg," with the narrower end as the chin. Depending on the person, you can make their face wider or narrower, but this is the basic front-on shape. Note that male faces often have wider jawlines than female faces.

2 **Dividing lines** Draw a horizontal line across in the approximate middle of the face. Along this horizontal line is usually where the eyes and ears will be located. Beginners are often surprised to realize that the eyes are in the middle of the face, not near the top. It's also good to think of the size of the eye as a basic unit of measurement in the face, with the two eyes being about an eye-length apart, and another eye-length on either side. Next, draw a vertical line down the middle. It is along this line that you will find the nose and mouth.

3 **Upside-down triangle** To locate the rest of the face in proportion to the eyes, draw an upside-down equilateral triangle from the outside corner of each eye downward. The bottom corner pointing down will be at about the base of the mouth. Every face is different, and this is only the case for mouths that are closed or just slightly open, but this is still a good basic guideline to use.

4 **Line up the ears with the nose** The base of the nose is approximately one eye-width distance from the bottom of the lips. The ears, on the side of the head, measure roughly from the top of eyes to the base of the nose. Drawing a loose ear shape in that basic unit of space is all the quick sketcher needs to suggest the ear.

5 **Alternative angles** The above steps are great when drawing heads face-on, but from other angles you need to remember the head is not flat, and all of these guidelines must curve with your basic egg-shaped head.

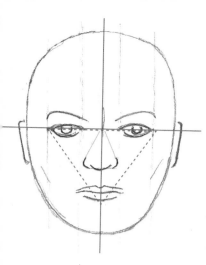

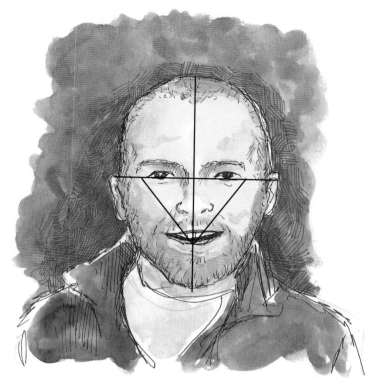

Above **Pete Scully**, *Basic diagram of facial proportions*, 2016.
This basic diagram shows the rough proportions to think about when sketching a head shape. Everyone's head is different, and you have to see through distracting details like hair or glasses, while keeping these general guides in mind when sketching faces.

Above right **Pete Scully**, *Face with diagrams*, 2016.
In this sketch, see how the triangle matches up roughly with the edge of the eyes and the base of mouth. When sketching faces, adding this triangle in with a light pencil or pen first will take the stress out of figuring out where things should go. Don't worry too much if their features don't exactly match this triangle — everyone is different!

Right *Measuring a head*, 2015.
This diagram shows the basic way to measure proportions of the head, with the width being roughly two-thirds the head's height, and the eyes running along the middle horizontal line.

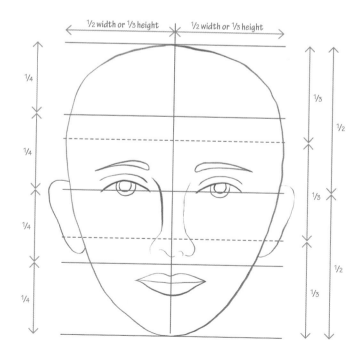

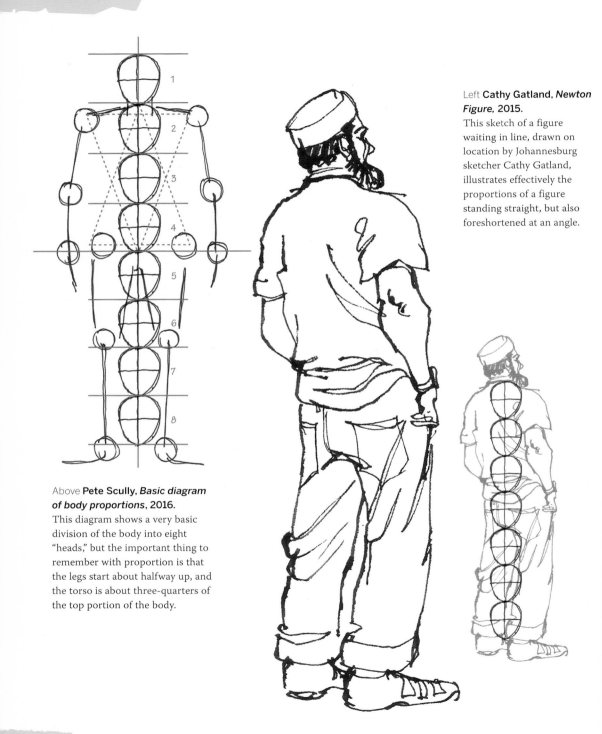

Left **Cathy Gatland, *Newton Figure*, 2015.**
This sketch of a figure waiting in line, drawn on location by Johannesburg sketcher Cathy Gatland, illustrates effectively the proportions of a figure standing straight, but also foreshortened at an angle.

Above **Pete Scully, *Basic diagram of body proportions*, 2016.**
This diagram shows a very basic division of the body into eight "heads," but the important thing to remember with proportion is that the legs start about halfway up, and the torso is about three-quarters of the top portion of the body.

Basic proportion: bodies

With quick five-minute sketches you aren't necessarily going for perfection, but understanding a few basics about body proportions can make all the difference, whether drawing a single person or a crowd. Just knowing a few tips can help you avoid common pitfalls and draw great quick people!

Tips to get you started

1 **Measuring in heads** On average, the adult human body is about eight "head sizes" in length. This is good to know, but you will not be measuring in heads every time you have a quick sketch to do, so it's good to just practice that a little bit first to get the hang of proportion.

2 **Torso shape** It's sometimes helpful to think of the torso as two long overlapping triangles taking up the space between the head and the middle of the body (roughly three "heads" in length). The chest is usually broader in men, while in women the waist is often slimmer. Shoulders are often about a couple of head sizes apart, while arms will stretch down to just below the waist.

3 **Length of the leg** The legs take up at least half the body length, with the knees positioned a little less than halfway between the waist and the ankle. The legs are usually the body part that can be stretched a little if needed (think of the way fashion illustrators draw their models), but try not to make them too short. A common trap is not to give yourself enough room on the page for the legs — but it's better to cut off the feet than squash the legs!

4 **The side view** While the basic measurements still apply, there are different proportions to consider with the side view — the shape of the head in profile, the position and angle of the neck (which slants forward rather than rigidly upright) and which parts of the body stick out more than others. Breasts tend to come down at an angle before curving in above the midriff, while the back is never completely straight and curves outward again at the base of the spine. All body shapes are different and the side view may give the most variation between subjects.

5 **Practice with stick figures** With the basics in mind, practice by drawing a set of simple stick figures in a variety of poses. These should only take a few seconds, so you can draw as many as you like — but keep the poses realistic. The human body can't do everything! Using a posable wooden mannequin for reference can be fun, but not as much fun as observing real people and imagining them as stick figures. In the long term, that will be more useful.

Basic arms and legs

Arms and hands are probably the most expressive and flexible part
of the human body. Their position can dictate the mood and meaning of
a sketch almost as much as putting in a speech bubble. Legs and feet, on the
other hand, are generally more utilitarian, quite literally supporting us,
but are important to body language in a more subtle way.

Tips to get you started

1 **Simple arm shapes** Try sketching someone's arm by starting with basic oblong shapes and then molding the shape with your pen. Don't forget that arms don't have straight outlines but curve slightly with the shape of the muscle. The upper arm below the shoulder to the elbow looks shorter than the lower arm but is in fact slightly longer — a straight wrist can be deceptive. Usually the lower arm will be thinner than the upper arm.

2 **You need hands** Arms can get us where we need to go, but hands do all the talking. Too often an afterthought, a hand can make or break a sketch. They aren't easy to draw, so observe and practice as much as you can. For a quick sketch, really focus on the direction and length of the hand in relation to the lower arm. Use minimal strokes when adding the fingers, so as not to overcomplicate the hand gesture.

3 **Let's see those legs** When drawing legs, the thigh will usually be thicker than the calf, but the calf is usually longer. The front of the calf will usually be straight, while the back has a more graceful curve below the back of the knee.

This is generally true for most body types, slender or stout. Often when sketching people their legs will be covered, so the outline will be a bit rougher than an actual leg's outline, but the proportions will be the same. Watch for the feet! They will almost always be at a forward facing angle from the leg if standing, but are a lot more flexible in walking or seated positions.

4 **Knees up** Knees may stick out more when the leg is bent, but a straight leg can show off the knee's shape. With a quick sketch, even a small curved stroke to suggest the knee can make all the difference. If drawing a leg from behind, you won't see the knee, so distinguish between the upper and lower leg by slightly curving both sides of the leg inward at the middle.

5 **Striking a pose** Expressive poses, such as stretching out the arms or lunging with the legs, can be good practice, but try making the more subtle poses, such as folding arms or standing with one leg slightly bent, more interesting. Let this body language tell your subject's story.

Right **Kalina Wilson,** *Blue-haired model*, 2014.

Sketching posed models — such as at life drawing classes or at fun events like Dr. Sketchy's, where the models are usually costumed — may not be from "real" life exactly, but it gives you an opportunity to really study the human form, even in a five-minute sketch. Here, Kalina Wilson has captured both the arm and leg postures of this model with ease. Note the position of the model's right hand, suggesting the position of the unseen arm.

Below right **Rolf Schroeter,** *Ostbloc*, 2015. Rolf Schroeter got a great view of outstretched arms and legs in a bunch of poses, sketching people as they scaled a climbing wall in Berlin. He kept the angles and shapes simple but in realistic poses.

Below **Pete Scully,** *Sketching lady*, 2010. In this sketch the woman's arm is bent as she keeps a tight position while holding a sketchbook. Her arm is the most prominent feature, and the top half is much thicker than below the elbow, narrowing further at the wrist to accentuate the hand.

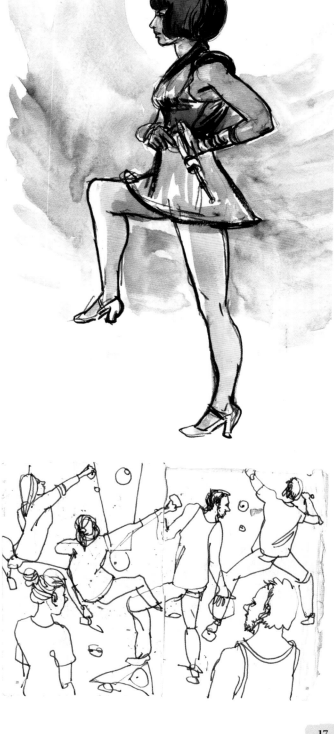

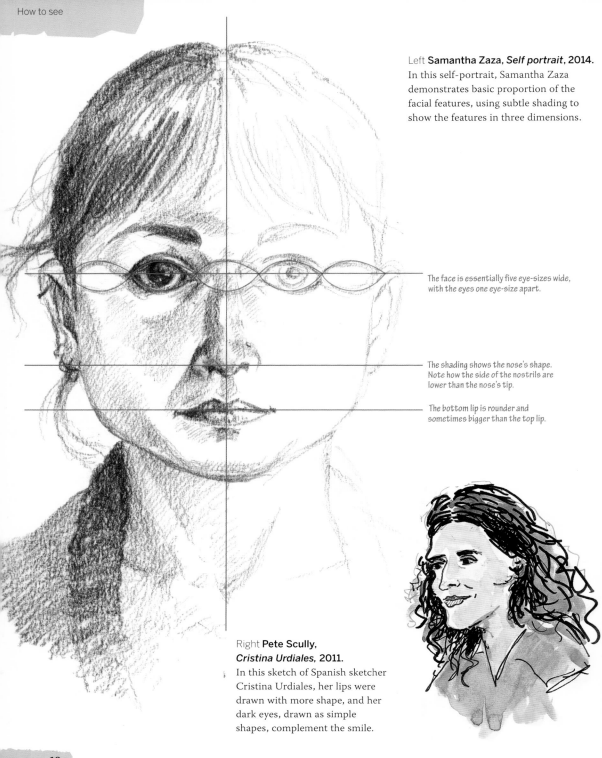

Left **Samantha Zaza**, *Self portrait*, **2014**.
In this self-portrait, Samantha Zaza demonstrates basic proportion of the facial features, using subtle shading to show the features in three dimensions.

The face is essentially five eye-sizes wide, with the eyes one eye-size apart.

The shading shows the nose's shape. Note how the side of the nostrils are lower than the nose's tip.

The bottom lip is rounder and sometimes bigger than the top lip.

Right **Pete Scully**,
Cristina Urdiales, **2011**.
In this sketch of Spanish sketcher Cristina Urdiales, her lips were drawn with more shape, and her dark eyes, drawn as simple shapes, complement the smile.

Easy facial features

We look at faces all the time, but converting them into a drawing is often a challenge. With a quick sketch, it's important not to overdo facial features — stick to the basic elements. Just the right amount of detail will make your quick sketch shine with expression.

Tips to get you started

1 **The eyes** Arguably the most important part of the face, the eyes can be the trickiest to get right. In a hurry, the important elements are the eyelid, the iris and the eyebrows. For a more complete eye, picture the basic almond shape but with a slightly flatter lower edge. The circular iris will be partly obscured by the eyelid. Eyebrows convey mood, so be careful not to make them appear too "angry." Watch for lines at the corner of the eye if your subject is smiling. If they are wearing glasses — or better, sunglasses — eye sketching will be a bit easier!

2 **The nose** Noses are such an awkward shape. In profile they are slightly easier, being roughly triangular in shape. The tip and the nostrils are the important elements; two rounded curves on each side of a small middle downward curve is all you need. Adding an extra line down the side of the nose from the eyebrows helps give the impression of its shape. It's worth practicing noses, so you have a toolbox of different shapes to draw on.

3 **The mouth** If your subject is happy, or pouting, or speaking or singing, it is the mouth that tells us. Focus on the most important elements — first the opening (whether open or closed), then the shape of the lips. For the teeth, don't draw them individually but leave the overall shape white. In a simple smile, the interior of the mouth will likely just be the teeth, but if the mouth is more open, as when laughing or in conversation, add a dark area beneath the top teeth. Add lines from the edge of the lips to the side of the nose to broaden the smile.

4 **The ears** Looking at them, it might seem that ears are almost deliberately difficult to draw. Go for the most simple version in your sketch — the half-shell shape halfway up the head, with the lobe meeting the jawline. Instead of focusing on the tricky details within the ear, a simple "S" shape (inverted on the left ear) is usually enough.

5 **Everything else** The chin is important; if it's too far from or too close to the mouth, the person will look out of proportion. Watch for the chin's shape. In heavier set faces the chin line may be above the bottom of the face shape. Similarly, adding lines on the cheekbone may make a figure seem too gaunt or too old.

Hair in a hurry

Hair can either be the most intimidating or the most fun part of the human body to sketch, and it's where you will find the most variety. Dark hair will shine in unusual ways, long hair will change shape depending on the head's position or the wind, curly hair will make unexpected shapes and don't forget all those beards; hair can often be the aspect that draws you in the most, so don't brush over it!

Tips to get you started

1 **Shape of the head** Hair often masks the head's shape, so take the time to observe whether the top of the hair is about level with the skull or, as is usually the case, slightly above it. The same goes for the rest of the head — if someone has long or bushy hair, imagine them bald and add the hair shape on top. See the hair as a single shape and draw that as an outline.

2 **Shine and shade** Hair reflects light in unexpected ways; even the darkest locks appear light in places. Try to leave the highlighted parts clear of line, and darken the shaded areas such as the edge of a fringe. It can be a fine line between suggesting light and suggesting graying hair, though, so practice. Think also of how comic books used to depict black hair as generally blue with black shades.

3 **Detail** In a quick sketch, the fewer details to convey the hair the better, but if sketching without color, remember that heavier details will depict darker hair, while using fewer marks will suggest a much lighter color. Light blond or white hair is often best sketched with detail only at the very edge, and the rest left blank. Define a few key areas; you won't be drawing

every hair, but the lines of the hair's direction mean you can use lines to suggest the hair's flow more than with, say, skin. Don't be afraid to scribble; hair doesn't need to be perfect! A wash of paint or a few lines of colored pencil over a quick ink sketch can suggest color.

4 **Draw the back** If you are in a meeting or on the bus, drawing the back of the head of the person in front of you is a good way to study how to draw hair. If someone has long hair you can really take note of how it falls down; straight hair will take up less space than curly hair. If the hair is thinning, don't leave out bald spots.

5 **Beards and mustaches** If sketching someone with a big, bushy beard, look at the beard's overall shape, and also how it connects to the side of the face. Remember the proportions and position of the mouth; you may only be able to see the bottom half below the mustache. For more trimmed facial hair, go easy on detail, and with unshaven stubble, a few small suggestive marks are all you really need.

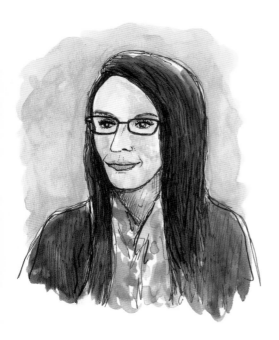

Left **Pete Scully**, *Kim McMullen*, 2015.
I sketched my University of California, Davis colleague Kim at our department's holiday party — a good place to practice your quick people sketches. It was important to draw the lines of her hair in a uniform direction, and also to keep the parts near her skin dark to emphasize her face. For her scarf, which was highly detailed, I kept it simple with a few dabs of colored paint. I added the colors after the initial ink sketch, which was done rapidly, while students sang karaoke in the background.

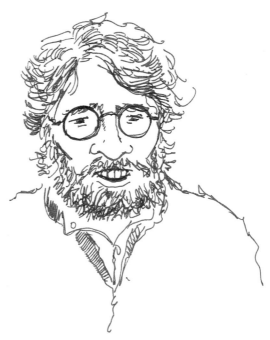

Below **Pete Scully**, *Bearded man*, 2010.
I sketched this man while out and about, and loved his amazing beard. With hair this light, it's important not to add too many details, especially when drawing in pen, otherwise the values will get too dark.

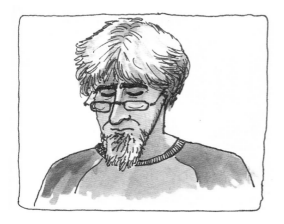

Above **Pete Scully**, *Allan Hollander*, 2012.
Allan is a fellow sketcher in Davis, CA, and I have sketched him many times because he usually sports a fantastic beard (with a great smile, too). This was sketched in a couple of minutes with quick pen strokes to show off the beard's unkempt quality.

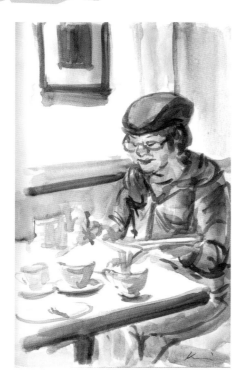

Left **Kumi Matsukawa,**
Cake and sketch, **2014.**
In this quick watercolor, Tokyo-based
artist Kumi Matsukawa enjoyed a
"cake and sketch" session with her
students. The scene is composed
nicely, with the angle of the table
and the angle of the wall framing
the middle of the sketch, while the
woman seated sends her gaze in
the direction of the various objects
on the table, drawing us there,
as well.

Below **Pete Scully,**
Barcelona dinner, **2013.**
After a busy few days in Barcelona,
Spain, I joined some of my urban
sketching friends from around the
globe for dinner. We sketched each
other, shared stories, had fun. Four
continents are represented in this
sketch alone; members of the fifth
were on the other side of the table
next to me. I kept each portrait quick,
and made heads a little larger to fit
them all in.

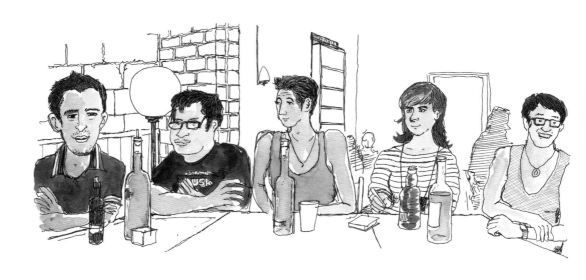

Quick composition

What makes for good composition in a sketch? Sometimes that is a matter of taste, but a well-balanced composition can make even the most rapid five-minute sketch more interesting to look at. Knowing a little about perspective helps, but there are other ways to draw the gaze around a sketch. Taking a few seconds to think about your composition will make all the difference!

Tips to get you started

1 **Map out in pencil** Using a pencil or light marker, quickly map out some compositional lines that you'd like to follow. Look for the basic shapes; chances are you won't stick rigorously to them, but they are just a guide. Then, with a different pen, you can add in the figures and objects of your sketch.

2 **Composition tools** Classic rules of composition like to discuss the "rule of thirds," dividing the paper into diagonal and horizontal thirds as markers for good, non-centered composition. This can be a useful starting point, but don't follow it too rigidly. A good composition tip when drawing people is to have one or more "dominant" figures and have the other figures placed in connection to them.

3 **Directions** When composing a group of people, look for the natural directions in the scene. Aside from the perspective lines, are people moving in a certain way? Are they looking or gesturing one way, while others look elsewhere?

Look for different lines of action, and sketch those basic directional lines in first before adding the people. These will let the eye travel through the sketch.

4 **People of all sizes** When sketching a group of people, be they passers-by or people lining up for coffee, try to emphasize their different heights. This will make the composition more interesting. You might want to add people in the foreground closer to you; this will automatically add depth to any quick sketch, and will break up the repetition of the main view.

5 **Let it come naturally** When you only have five minutes to sketch, there won't be time to worry too much about perfect composition, so it is better to just draw and let the composition come naturally. Once you start playing around with different sizes and shapes, you will discover which composition feels right to you.

Fast backgrounds

All too often our people sketches are just that — the people, and nothing else. When sketching on location, it is a good idea to get even a little bit of background in, to place people geographically in a real setting. Or perhaps you want a background to help make your subjects stand out more.

Tips to get you started

1 **Keep it simple** Once you've sketched your person you'll probably be short on time, so you might just go for a few very quick elements, such as the shape of the trees across the road, a loose line showing the curve of the street or perhaps the outline of the rooftops behind them. Bookshelves make nice backgrounds, and can just be a row of very quick strokes. Pen or pencil works, but consider a sketchy background in watercolor. Just one or two very basic, loose lines can make all the difference.

2 **Add a single object** If there is a street sign, or a fire hydrant or a frame on the wall, add that single element by itself near to the figure or figures you are sketching. This one element will tell us immediately where they are, or at least give us an idea.

3 **Quick stick people** Adding more people to a sketch might mean more sketching time, so consider adding them in the most basic of detail — stick figures really — and perhaps in a different color or line size to the dominant people you have drawn. If they are simpler looking figures, the focus will still be on your main subjects.

4 **Abstract text elements** If you are in a café or bar, why not add its name across the background, perhaps in colored pen, using interesting lettering? Maybe the background can be a mishmash of things your subject said while you were sketching them, or the lyrics of the music that was playing.

5 **The quick wash** If you are stuck for a background but don't want to leave the page blank, add a little wash of color around the figure, or some crosshatching in colored pen, so that your subject can really pop off the page.

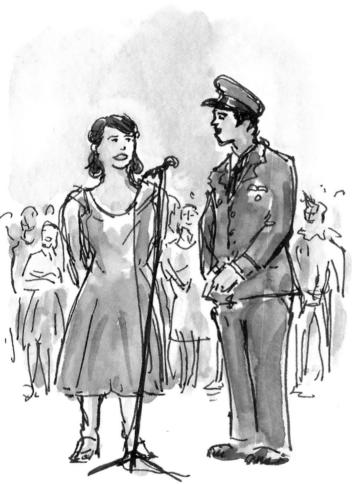

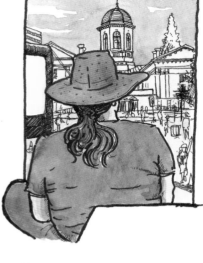

Above **Pete Scully,** *Kalina's red hat,* 2010.
I sketched Kalina from the rear while she drew Courthouse Square in Portland, OR, using her red hat as the main focus of the sketch. I enclosed the background within a frame, as if to emphasize that was the subject of her own sketch.

Above **Pete Scully,** *Park performers,* 2015.
These young actors were performing numbers from a musical in a local park, but the figures alone looked too isolated. Adding the background of people behind them — simple figures but still showing their smiles — was enough to place them in a real location, but the perspective also shows their position in relation to the sketcher.

Right **Pete Scully,** *De Vere's woman seated,* 2013.
In this sketch, the seated figures might have been enough, but the addition of the quickly drawn partial picture frames, as well as the woman's shadow, adds another level of depth. Even small background additions can make a figure appear more comfortable.

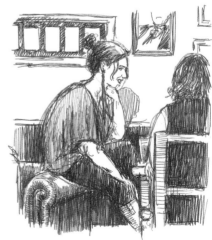

Play with perspective

When we think about perspective in art, what usually comes to mind are detailed drawings of architecture, lines heading mathematically toward various vanishing points — a skill for the more advanced sketcher. But did you know that not only can you apply these rules to people, but also sketching people can actually help you to figure out perspective?

Tips to get you started

1 **Vanishing points** You can think of perspective as a series of lines leading toward a "vanishing point." Practice finding a vanishing point by drawing two figures, in proportion, but one smaller than the other. Then draw a straight line connecting their heads, and another their feet. Continue the lines until they meet; that is the vanishing point. Your two figures at first appeared to be different sizes, but now appear to be the same size, drawn in perspective.

2 **Eyes on the horizon** The first rule when figuring out perspective is to find the horizon — that is where the vanishing point will be found. Here's a tip — it's always at your eye level. So if you draw anything while standing up, switching to a seated position will actually have a huge effect on the perspective.

3 **The line of heads** If you are standing drawing a group of people who are around the same height as you, their heads will be level with the horizon. If you are seated, the line of their heads will angle down toward the vanishing point. However, bear in mind that people are all different heights!

4 **The line of feet** People's heads might be at different heights, but on flat ground their feet are all in the same place. If sketching a group of people in a line or even a crowd, you can follow the line of their feet directly to the vanishing point. It's worth going to a public place like a market and practicing this. If someone in your sketch appears to be floating, check their feet against a perspective line.

5 **Curving perspective** In a five-minute sketch you are unlikely to have time to play with curved perspective. But why not — and what is it exactly? You can think of curved perspective as akin to a "fish-eye" lens. Take a horizontal line, mark two points on either end, then draw a circle from point to point. Then draw curved lines within the circle from point to point, making it look a bit like an eye. That's no coincidence — we see a "curved" world thanks to our round eyes. Draw some figures against the lines to get the basic idea. Practice it in a lecture hall or church; sit in the middle and quickly sketch the row of people in front of you.

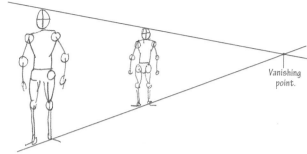

Right **Pete Scully,**
***Perspective of two people**, 2016.*
Placing two people of identical
proportion but different sizes in
different locations on the page gives
the impression of perspective, but the
vanishing point also gives us an idea
of your location as the sketcher.

Vanishing
point.

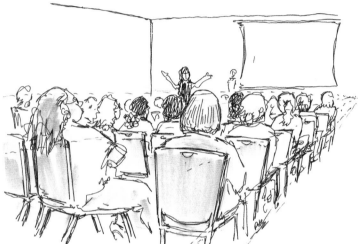

Left **Pete Scully,** *Meeting
perspective, UCAAC,* **2014.**
Sketching in meetings or lectures is
a good place to practice perspective.
This five-minute sketch was drawn
from the back of the room, slightly
off the main pack. The horizon being
at eye level, most people's eyes in the
room are roughly at the same height,
since I, the sketcher, was also seated,
but the feet move up the page toward
the vanishing point.

Right **Gabi Campanario,**
***Portland sketchers**, 2010.*
Sketching people seated from the
side gives you an opportunity to
practice perspective using people.
In this image, Gabi Campanario drew
three urban sketchers, Gerard, Doug
and Cynthia, as they sat on some
Portland, OR, steps capturing the
world in their sketchbooks. The quick
lines of the steps are a rough guide,
and even though the people are
seated at different levels, the
perspective is spot on, while the
addition of the building and bike
behind adds to the illusion of depth.

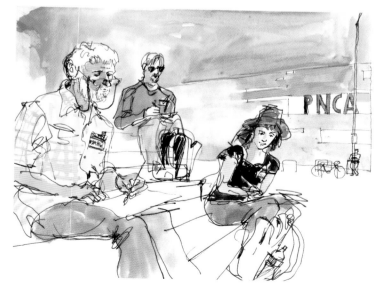

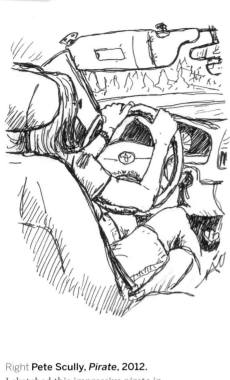

Left **Pete Scully, *Angela driving*, 2009.**
This sketch of my wife driving up to Oregon was made while I was sitting in the back seat entertaining our then-one-year-old son. As an exercise in sketching in a moving vehicle, I had to focus on the perspective of sketching someone at a certain angle, when the foreshortening can be tricky. Having the features of the car to "cling on" to helped me figure out the depth of the image.

Foreshortening the head.

Composition directed upward.

Right **Pete Scully, *Pirate*, 2012.**
I sketched this impressive pirate in Portland, OR, from a close-up position beneath him. His head is foreshortened in comparison to his body; his triangular tricorn hat helps direct the composition upward.

Body gets smaller as you go toward the head.

Drawn from beneath, the legs are drawn larger.

Focus on foreshortening

When sketching people from even a small distance, you are usually going to have features appear roughly in proportion. But if drawing someone with their arms outstretched toward you, or from above looking down or even from below, it helps to know a little about something called "foreshortening." Foreshortening is a perspective term that simply means making objects in the distance smaller than in the foreground. When drawing figures, it's a handy way to give your sketch more depth.

Tips to get you started

1 **Practice perspective** It's good to imagine perspective lines around a person. If they are stretched toward you, it is easier — try to find the vanishing point. Imagine the way comic books have dramatic "fist-at-the-camera" poses. While real-life drawing is less dramatic, the same guidelines apply.

2 **Big feet** Practice drawing someone lying down, but draw them with the feet closest to you. If you draw the feet in proportion with the head you will lose the effect of them lying down, so draw the feet largest, with every part of the body getting slightly smaller as you go toward the head. Draw them again looking from the head toward the feet; you'll find those feet are now much smaller.

3 **Draw from above** Drawing people from above, the head will appear larger and the feet smaller. Drawing each section of the body as an overlapping balloon shape, with curves pointing down, often helps. Your location determines the angle; choose a spot which is overlooking people walking one story below you and sketch people at different distances from above.

4 **Foreshortening the head** It's tricky to foreshorten the head from the side. The most common way to use this effect is with the eyes. When the face is turned at an angle, the closest eye will appear bigger, since the other is farther around the face. Since the face is not flat, features on the far side not only foreshorten, but also are hidden a little more.

5 **Don't overdo it** If someone is posing with a hand stretched toward you, how big you draw the hand will depend on how close they are; if they are right next to you, the hand will be a lot bigger in proportion to their body than if they are farther away. Be careful not to overdo it, or their arm will appear too long.

Catch negative space

The term "negative space" is used a lot in art to describe the areas between objects or people. This area is often left out, but focusing on it allows you to see the real shapes of the things you are drawing and how they relate to one another. Just a little thought about negative space can boost your composition skills.

Tips to get you started

1 **Draw the outline** A common exercise is to draw the outline of an object or group of objects, and shade the space around it. Try it with a chair, or other inanimate object, then try it with a person or group of people. If they are standing still, it helps you see their shape and the shapes between them. Just shade in the negative space: don't worry about details. This will help you to see those shapes and be more conscious of them.

2 **Recognize the shapes** Draw a group of people you know seated at a table. Draw just their outlines very lightly in pencil, as well as the table and objects such as bottles and glasses. Don't draw the lines where these objects meet. The group will be one whole single mass. Watch for the spaces between feet and chair legs and include that negative space in your sketches. Then, using a marker (or similar), quickly add a single-toned background within the spaces between and around them. Can you still recognize the people by their shapes alone?

3 **Passers-by in the street** When drawing a street scene, people in the foreground often help to break up the patterns behind. Draw the outline of some passers-by, and then spend a few minutes sketching the details of the scene behind them, filling in the negative spaces with actual scenery rather than blocks of shade.

4 **Composition play** Once you start seeing negative space, think more about the composition of your scene. If drawing a group of people, are they all oriented in the same direction? Are any standing, or pointing or holding up drinks? Use the negative space to highlight the shapes between people having a conversation. You might even fill those negative spaces with their words!

5 **Reverse negative** Rather than leave the people as blank objects, use a marker to draw them as solid black objects. Then with paint or colored pencil, focus on coloring in the background within the negative spaces. Draw a box around the scene with a marker; the colors will pop.

**Right Pete Scully,
Figures standing, 2016.**

The two figures in the middle were closer to where I was sitting, and were standing close to each other from my perspective, so their shapes were mingled more. The two figures in the background were standing apart, but at the same distance from me, making the space between them more interesting.

**Below Cathy Gatland,
Fordsburg women, 2016.**

In this sketch, South African artist Cathy Gatland illustrates negative space with some more definition. These three women were weaving very quickly through the streets and cars; their general shapes were jotted down and details of what they were carrying added as Cathy caught glimpses of them here and there.

**Above Pete Scully,
Seated figures at lunch, 2016.**

I was sitting behind these figures eating lunch at an elevated table. There were several tall chairs; it was tricky to find the gaps. Sketches like this force you to test your observation skills.

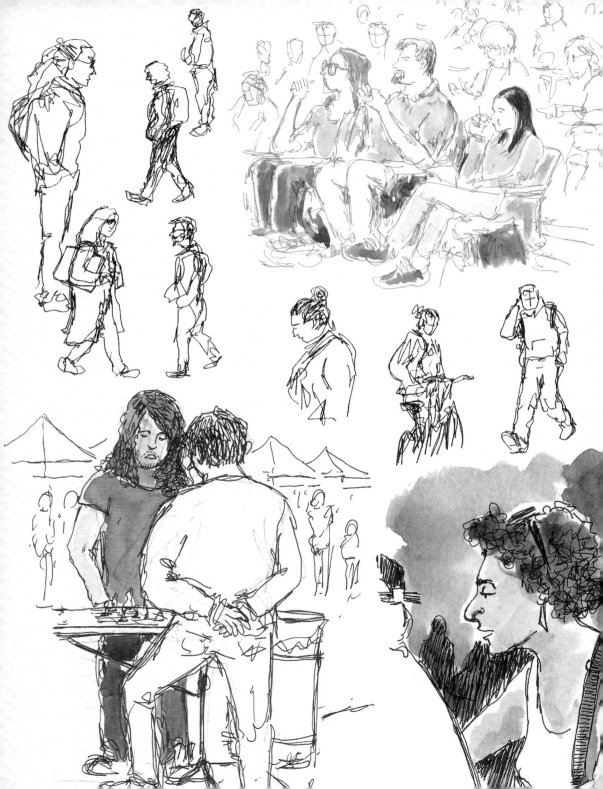

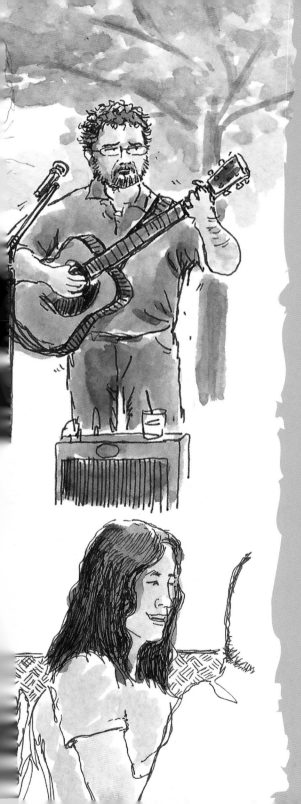

Quick on the draw

Drawing people on the go, you have got to be fast. If you don't have the time for life model sessions or to sit in the comfort of a studio doing perfect portraits, sketching on location is the best way to hone your quick-drawing skills. You might be drawing friends; you might be drawing people at a café, or passers-by in the street; you might even be sketching a quick selfie. As you sketch, you will learn to spot common poses, and discover simpler ways to show someone's action or meaning. Push your boundaries; try sketching people moving about — sports players, dancers or just people passing by in the street. In many cases, you may have only a few seconds to record them, so you will start to strengthen your memory and observational skills, and let your pen or pencil go on a journey with you.

Left From playing chess to playing guitar, to walking, talking or listening, these people are engaging in the everyday, sketched in the act.

Below **Pete Scully,**
Cris Breivik, 2014
This portrait of Cris Breivik
was drawn at the end of the
University of California
Academic Advising Conference,
Davis in 2014, where I was the
official sketcher. I wanted to
catch Cris's personable smile
and including the lime green
badge of the conference places
this sketch at a date known to
the subject.

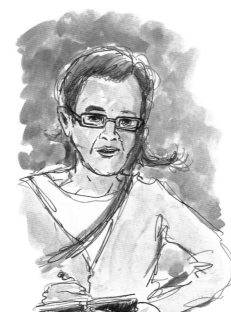

Left **Pete Scully,**
Isabel Fiadeiro, 2011.
Sketchers sketch each other,
and when they do, about half
the time they will naturally
coordinate so they both look
up at each other and down at
the sketchbook at the same time.
This sketch, of Mauritania-
based urban sketcher Isabel
Fiadeiro, was done in five
minutes flat at a café in Lisbon,
Portugal, with a colored pen
being used to make the sketch
more vibrant.

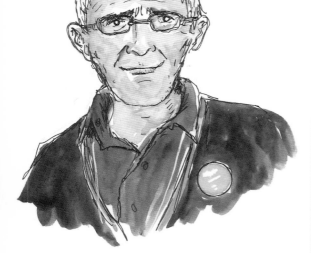

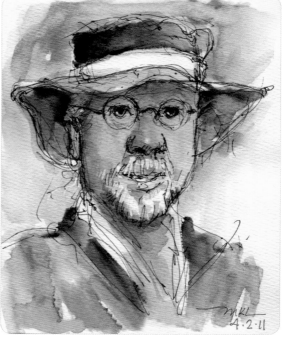

Right **Marlene Lee,** *Scott S*, 2011.
Scott Shepherd is another local artist
in Davis, CA, captured here elegantly
by Marlene Lee in ink and wash on
one of our sketch crawls. His warm
skin tones are complemented by the
cooler background.

Quick direct portraits

Sketching someone's portrait live can be scary. Not only are they watching you while you draw, but also there's an instant critique afterward; what if they think it looks nothing like them? Fortunately, the five-minute sketch means you can make the process much less formal, and less like a sitting for a portrait at the National Gallery. And most people do like to be drawn!

Tips to get you started

1 **Ask permission** It's nice to ask someone if you can draw their direct portrait. People may feel like they are being put on the spot when you draw them, so reassure them with a smile. Asking someone to pose for a few minutes is a way of making a connection. If sketching a stranger, let them take a photo of the sketch afterward — it's only fair!

2 **Don't worry about perfection** Sketching a portrait to a close likeness takes a lot of practice, and more often than not the subject will say, "That's nice, but it doesn't look much like me." You're not trying to misrepresent anyone, but with a five-minute sketch you don't have to worry about perfection. Sometimes getting one thing spot on, such as the smile or the eyes, can make the rest fall into place.

3 **Direction of the eyes** Having your subject look directly at you gets the nice face-on view, but you don't need to have them fix upon you for five minutes. Sketch them looking away, or with their face pointed to the side, so one ear is slightly out of view, for an interesting viewpoint. However, if your subject is looking directly at you the end result will feel a lot more intimate; eyes draw us into a drawing.

4 **Remember basic proportions** The eyes are roughly along the middle of the head shape, with each eye roughly one eye-size apart. However, be mindful that general guidelines shouldn't mean a generic portrait — focus on your subject's individuality and personality. Draw from life, too — your eyes can see personality and 3-D shapes far better in real life than in a photo.

5 **Do more than one sketch** If you have the time, ask if you can draw the subject two or three times, maybe in slightly different styles or materials. If it's hard to capture someone the first time, a second or third attempt may help. You can add a watercolor wash later if you like.

Speedy selfies

As long as you have a mirror, you'll always have someone to draw, right?
Yet sketching a selfie can sometimes be a little challenging. You're almost
always seeing the straight-on view, and sketching yourself in reverse to how
the world sees you. However, if it doesn't turn out quite right, you can
always keep trying — your subject will only get bored when you do!

Tips to get you started

1 **Mirror view** The mirror view can be quite intense. If using a smaller handheld mirror, try sketching your face from different angles. With the mirror below, you will see your nostrils in more prominence, while when sketching from an elevated mirror, your forehead will appear larger; you might notice more lines on your forehead as you raise your eyebrows to look up.

2 **Sketch from a device** When sketching yourself whilst looking in a mirror, you will only ever get the direct eye-contact version of your face. If you have a digital device with a forward-facing camera, try sketching yourself from the screen. As the lens is not where you will be looking, you'll automatically have a view of yourself looking off at an angle.

3 **Style exercises** If you have a bit of time — or even if you have just five minutes each day — draw a series of rapid selfies in different media and different styles. You can use this as a way of testing how you like those styles when sketching out in the real world. Sketching the same face over and over, you can start to see

your observational strengths emerge. What did I do right here? What can I improve upon there? Each one may be different, but that can be as much down to your own mood as your skill level. Try to express emotion, as well as reality.

4 **Draw the whole body** Usually when sketching a selfie, you will draw the head and shoulders, and this is natural — your mirror might just stop there. If you have a full-length mirror, try sketching yourself down to your feet. It will feel different, but is a good way to practice the full human form without a model. Try standing to one side and sketching yourself at an angle, or even drawing your head large and your body much smaller — it's a fun effect!

5 **Don't compare** It is easy to look at how you've drawn a selfie and how you draw others, but you will almost never get the same mirror view of others as yourself.

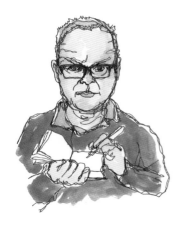

Above **Pete Scully**, *Selfie 24*, 2016.
Upon turning 40, I decided to sketch 40 five-minute self-portraits in one sketchbook using a variety of styles and media. This one was drawn with the fast single-line technique in pen, before adding in some watercolor. I included my sketchbook and the way I hold my pen — more of a visual marker for me than my own face!

Below **James Hobbs**, *Selfie*, 2015.
London-based artist James Hobbs draws himself here in his trademark pen style with a smile and from a slight angle. While using a fairly thick line he has still added simple detail to great effect.

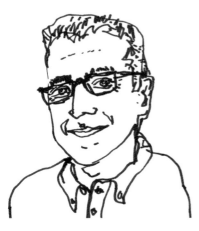

Above **Patrizia Torres**, *Autorrazul*, 2012.
Spanish urban sketcher Patrizia Torres likes to sketch a little bit and relax before going to bed, but here the big mirror of her hotel room was irresistible, so she had to do a self-portrait.

Easy profiles

Sketching a person in direct profile can be the best way to show the real shape of somebody's face and head. For a quick sketcher it can seem a little easier than a more angled side view and less intimidating than a direct portrait. However, you might wind up with a drawing that appears a little flat, so knowing a few basics will make all the difference.

Tips to get you started

1 **Focus on the nose** Remember, the nose sticks out the farthest in a profile. Noses come in all shapes and sizes; some are stubby, some point up slightly. Don't be afraid to draw a long nose if your subject has one! Use the nose as a starting point for figuring out the rest of the facial shape. Recall that the nose curves around at the bottom to meet the top lip.

2 **Just one eye** When drawing the eyes, remember that in a profile you'll only see one of them. Try to observe how far back the eye is set. Generally you'll want to draw the eye as a basic triangle, with a curved edge facing outward. The eyebrow will usually come down to almost the edge of the profile, and male faces often have heavier set eyebrows than female ones.

3 **Line up the ears** The ears on a profile are usually just left or right of center toward the back of the head, and if the subject is looking forward, then the ears usually line up with the nose. If drawing the cheekbone, which is between the ear and the nose, try to be as subtle as possible; too heavy a line will make it appear too sharp or prominent.

4 **The shape of the skull** The back of the head is not flat, either, but usually curves outward. Try to think of the bulbous shape of the skull, even if the head's outline is obscured by long hair. Don't stop at the neck — try to get some of the subject's clothing and shoulders in, as well, if you can. You can get a greater sense of their posture this way than from the head alone.

5 **A well-proportioned profile** If you're ever in need of a quick example of a well-proportioned profile drawing, check your pockets for coins. If you are from a country with monarchs or presidents on your coins, take a look at how their profile was rendered and follow the same guidelines. Of course, you may end up making your subject look a bit like a queen or king!

Profile of Queen Elizabeth II.

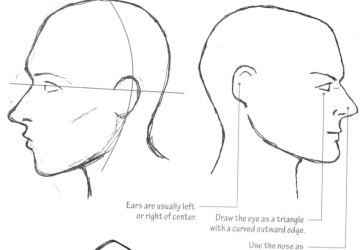

Left Pete Scully,
Profile examples, 2015.
These examples show two different basic profile shapes. Note how the jawline moves up toward the base of the ear.

Below Pete Scully,
Alanna Randall, 2011.
Fellow sketchers are the best subjects, and they also understand when you don't capture them quite perfectly! Alanna was at the second Urban Sketching Symposium in Lisbon, Portugal, and I drew her while she watched a lecture. Profiles often make people look much more serious than usual!

Ears are usually left or right of center.

Draw the eye as a triangle with a curved outward edge.

Use the nose as a starting point.

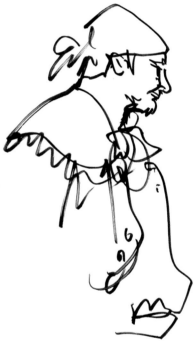

Above **Kalina Wilson,** *Swashbuckler's Ball*, 2013.
This loose ink sketch of a pirate by Kalina Wilson shows more of the figure's profile, including his body, and is drawn at a slightly lower angle for another aspect of the profile. The facial features are still prominent, but the tilt of the head is evident, and makes for a more interesting sketch.

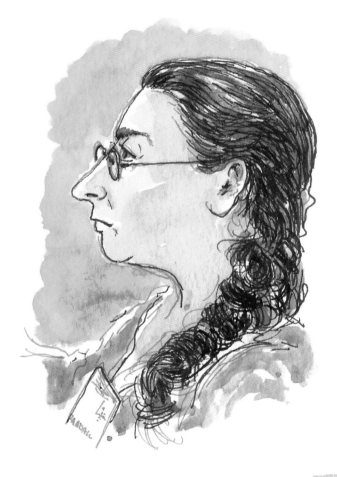

Playing with posture

We were all told to sit up straight as kids, not to slouch, to keep our heads up when we walk. A person's posture can be as important a characteristic as their hairstyle or their smile. For the five-minute sketcher, knowing what shapes to look for when drawing someone's posture can quickly add a whole lot of character to your sketches.

Tips to get you started

1 **The body's lines** It's a good idea to imagine lines running through certain parts of the body — vertically from head to feet (or head to the pelvis), horizontally from shoulder to shoulder, horizontally from hip to hip. In a casual standing position the two horizontal lines aren't usually parallel — one slants up, so the other slants down. From the front, the vertical line appears to run straight, but from the side it will curve depending on their posture.

2 **Balance** The human body by itself may appear symmetrical, but in practice people tend to lean one way and stretch their leg another, even if only slightly. Our bodies automatically balance themselves, so remember this balance when sketching. Also, we tend to take our body's weight on one side, making one leg straight and the other more relaxed.

3 **Character** Posture can reveal a person's character. A lazy looking person will slouch more, an angry person has tense features and a perky, energetic person might have their neck straight and much more symmetry to the way they stand. Exaggerate posture to tell a story!

4 **Age through posture** The way people stand at different times of their life is also interesting. Young children tend to stand straighter, while teenagers, new to their height, will slouch a lot more. Middle-aged people often have a more relaxed, generally upright posture, while older people often hunch down a little with slightly bent legs. Try to look for posture patterns among different age groups, and between genders, as well.

5 **Quick posture** Go to a place where people of all ages might be, and draw people as simple stick figures, taking care to observe the body's lines of posture. Life drawing classes can be good for studying the human form, but the real world is where you will see natural poses. Seated postures can be interesting, too. Does it matter what they are doing — reading a book or talking excitedly to a friend on the phone? Draw a diagram of someone's posture before adding in the rest of the sketch.

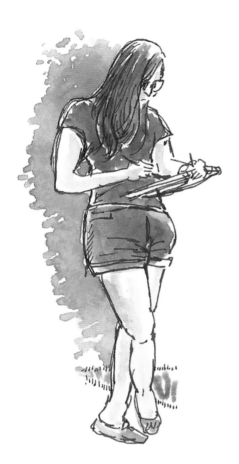

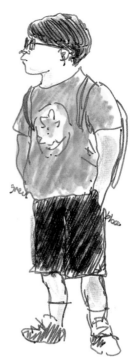

Right **Pete Scully**, *Bystander at Mondavi*, 2012.
This young man was waiting to rehearse a dance show at the Mondavi Center in Davis, CA. His posture shows he is not in a hurry, his feet are pointed apart and he is looking around to see if there is anyone he knows. I took little notes, so I could color in his clothes later.

Below **Pete Scully**, *Angela seated*, 2011.
I was interested my wife's seated posture while she was looking at the computer — the way her right arm rested on the mouse while her left arm supported her face. I made a few different sketches of this pose on the same page, overlapping.

Above **Pete Scully**, *Laura sketching*, 2010.
People stand in different ways when they sketch. Here, I sketched fellow artist Laura while she was sketching in Davis, CA, standing with her legs crossed for balance, while balancing her sketchbook against herself.

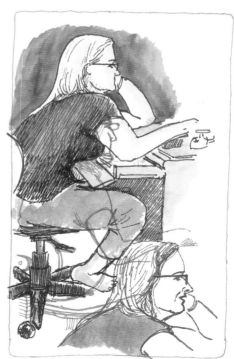

Below **Pete Scully,**
Seated sketchers, **2011.**
Sketched at a distance, these two ladies (and one dog) were busy sketching in the sunshine, sketchbooks rested on their knees. Chairs can be tricky to draw in perspective, and getting them out of proportion can make the figure look a bit too tall.

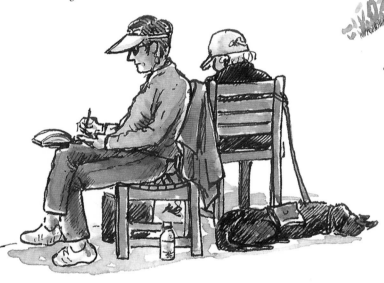

Above **Pete Scully,** *Rita Sabler in Barcelona*, **2013.**
I sketched Rita at the 2013 Urban Sketching Symposium in Barcelona, Spain. I was standing slightly higher while she sketched me. From this angle, it's worth watching the foreshortening and perspective.

Left **Patrizia Torres,**
The Concert, **2015.**
"I sketched my son while he was absorbed by Rachmaninov," says Patrizia. "It is great watching a teenager listening carefully to a violin and piano concerto, even if he is wearing a bathing suit."

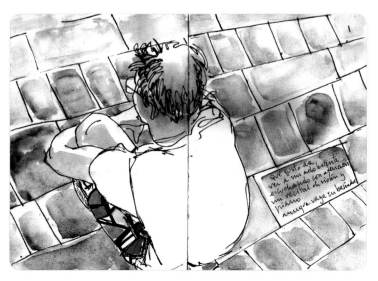

Simple seated poses

People who are sitting down are more likely to stay where they are than people standing up, and so make easy targets for sketchers, especially at public places like cafés or libraries. However, seated poses can be tricky to capture, and often carry a lot more expression than you might imagine.

Tips to get you started

1 **The hunched-over coffee drinker** Perhaps the most common sight you will see — the person hunched over a laptop or newspaper in a coffee shop, eyes on another world, maybe their chin resting on their hand. Draw from the side for the best effect. Watch for the way the neck stretches from the curved leaning torso, and take care to keep the arms in proportion.

2 **On the couch** This is more likely to be a comfortable looking pose, usually watching TV or reading a book, maybe partially lying down. Use more languid, less rigid lines, and softer tones, to portray the relaxing mood.

3 **Floor seating only** Children are more likely to cross their legs while sitting on the floor, just as they would at school, whereas adults often stretch them out, or sit on the side of their legs. When drawing crossed legs, the position of the arms is just as important, as they often balance the figure. Parks, beaches and children's sports games are good places to practice sketching these poses.

4 **Seated but animated** Being seated doesn't necessarily mean being still and passive. Your subject may be in conversation, or even in the act of eating or drinking — show them speaking, show them moving. Hands will move most, so position them where they appear most often — perhaps one hand resting on a leg, and the other gesturing.

5 **Watch the legs and feet** It is easy to focus on the top half while sketching people seated, but the way they place their legs, crossing them, letting them hang from a stool or even "manspreading" them, adds much more realism and character to the drawing, even if you don't draw the whole body. Proportion is key — watch closely for the size and position of the feet.

Play with repetitive poses

Whatever they are doing, people move about; you can't always expect them to stay still while you draw them. You might be drawing someone with their head resting on their chin and then they put their hands behind their neck. Try to focus on the pose they strike the most, and draw that. Chances are they will go back to that pose, making it easier for you to capture the essence of their action.

Tips to get you started

1 **Look for rhythm** Many repetitive poses are not random and can almost be predicted if watching carefully. A bartender may turn away at the moment you are sketching them in one pose, but will be back in the same pose at regular intervals. You don't need to limit yourself to one single sketch of an active person's poses, so try sketching three or four different poses a person may make. Draw quickly and draw often!

2 **Sketch people in a market** Market workers keep busy and make a lot of repetitive motions, most often handing their goods to a paying customer. Try not to focus on the more obvious poses, though; look for the ones that may be specific to their particular stall — the fishmonger filleting their fish, the grocer bagging up the carrots. Be conscious of how your sketch illustrates what they do.

3 **Find the common poses** When drawing a group of sports players, don't worry about focusing on individuals, just look for the most common poses, such as running or jumping. Certain people will do these things differently, but there will usually be a common pose to latch onto.

4 **Musicians** Certain musicians, such as guitarists or bassists, will not usually change their standard pose too often, while singers often move a little more. One handy thing is that when musicians start to play a song you will have at least three to five minutes to sketch them until the song is over — plenty of time!

5 **Public speakers** Like musicians, public speakers tend to repeat their poses as they talk, even if they are the sort to move around on stage. Do they lean against the lectern? How do they use their hands? How often do they look down at their notes or back at the projection? Their poses reflect their performance, so be mindful to represent them well.

Right Pete Scully, *David Hafter*, 2011.
Musicians playing publicly make very
good subjects, especially when they play
good music. I sketched local singer
David Hafter at the Farmer's Market in
Davis, CA, and knew that I would have
at least the length of the song to finish
the sketch. He made several different
poses while performing, but this one
was the most common.

**Below left Rolf Schroeter,
Swasky, 2015.**
Swasky is an urban sketcher from
Barcelona, Spain, here explaining his
techniques while being sketched by
Berlin urban sketcher Rolf Schroeter.
Rolf focused just on the upper half of
Swasky's body, not drawing his legs at
all, and his facial expression is as much
a part of his gesture as his hands.

**Below right Gabi Campanario,
Pete sketching, 2010.**
Gabi captured my own seated sketching
pose as I busily drew him. Even seated,
sketchers tend to shuffle, change
position or hold their books in different
ways, but in these drawings Gabi focused
on my most typical hunched-up posture
from two angles.

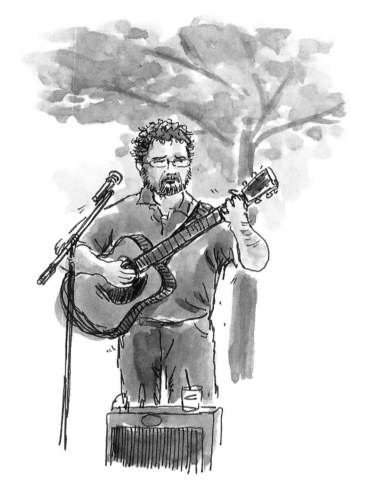

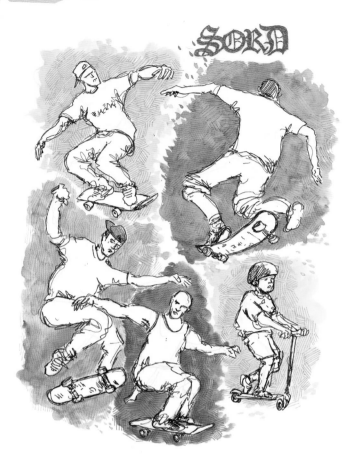

Left **Pete Scully, *Skaters*, 2014.**
These skateboarders were performing in the street to a decent audience in downtown Woodland, CA. I was looking for the most interesting poses, and obviously could not freeze them mid-flight, so had to rely on memory and watching repetitive poses. The color background was added later.

Right **Rolf Schroeter, *Fabiana Raban*, 2015.**
German sketcher Rolf Schroeter sketched this musician playing the cymbals with her hands, capturing not only the shape of the arms in motion, but also her eyes as she looked upward. Physically active musicians like this might make many poses, but this encapsulates a lot of the performance energy.

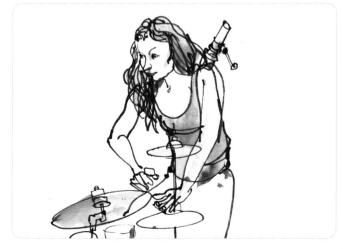

Speed up with dynamic poses

When sketching people from life, it's usual to draw arms and legs in fairly static poses, as that is how they tend to appear, but sketching in dynamic poses can make for a much more attractive sketch. A dynamic pose is one of action and movement, and when sketching from life it can take some careful observation to get right.

Tips to get you started

1 **Practice gesture** Gesture is very useful for making sketches feel more dynamic. Arms at the side and legs straight are not particularly dynamic; arms gesticulating or legs stretched out or in motion creates a more interesting image. The head, too, can express a lot of dynamism by its gesture — looking up, cocked to the side, looking behind.

2 **Line of action** This is a term used by animators to describe an imaginary line running down a figure's spine to make their characters' poses easier to understand. Try it out. If drawing someone in a dynamic pose, try to avoid a straight up/down line of action. A curved line of action will make a pose look more dynamic.

3 **Sketch the stretch** Most people you see out and about aren't going to be striking particularly dynamic poses, so look for places where people will be stretching — basketball courts, dance halls, the gym (if people don't mind being sketched while exercising). When people stretch they automatically look more

active, so look for the stretching motion when sketching, and focus on that.

4 **Loosen up to show motion** If your own lines are loose and applied quickly, you will convey motion better than when using clean, carefully drawn lines. Try using a fast and expressive medium such as a brush pen, or even sketch directly with watercolor paint. Poses will look more dynamic if there is a sense of movement, rather than someone making a static pose to "appear" dynamic. Try breaking the sketch down into simple shapes and stick figures.

5 **Location** Go somewhere where people are more likely to be making interesting dynamic poses. Sports fields, martial arts dojos and skateboard parks are good; farmer's markets and bus stations, where people tend to just mill about, are not. Skateboarders make good subjects; if they know you are sketching them, they are more likely to try elaborate tricks!

Draw the verb

All too often we draw the person and leave out the context. What are they doing? Who are they talking to? Are they walking down the street? Are they playing an instrument? Wherever possible, try to "draw the verb"!

Tips to get you started

1 **You're the director** Imagine yourself as the director of a movie in which there is no speech. How would you portray a scene without adding words or speech bubbles explaining what is happening? Try to make it clear what someone is doing.

2 **Quiet action** People may not be doing anything particularly active, but you can still focus on their action, even if they are just reading a newspaper or talking with friends. Simple poses reveal a lot.

3 **Superimposed sketching** Be playful with your line work, and draw in an "active" rather than "static" fashion. If you sketch someone and they change position, draw the next position over the top, or beside it. Don't worry about getting precise depictions; use the medium of drawing to achieve something different, yet still true to what you are observing.

4 **Relationships** If sketching people talking to one another or doing something together, how do you make it clear they are together? Adding eye contact between your figures is like drawing an invisible line joining them together. Body language is an important tool — let their posture and hand gestures tell a story.

5 **Context** Even in a quick sketch of a person, a few extraneous details can make all the difference. The dinner plate and glass in front of them need only be a couple of circles and lines, but immediately they tell us where the person is. The frame on the wall behind them; a few lines to represent the street they are walking down; even simple shapes and scribbles — all these give the viewer clues.

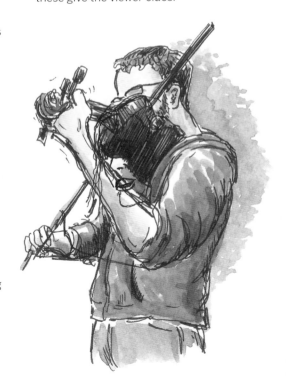

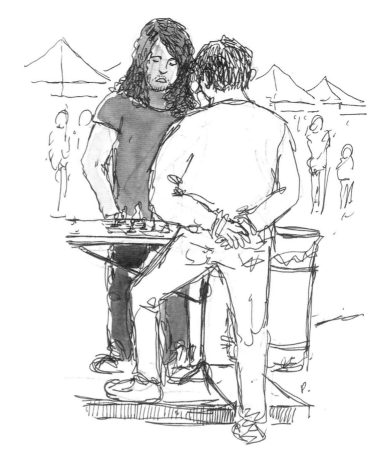

Opposite **Pete Scully, *Andy the fiddler*, 2011.**

I sketched this fiddler, named Andy, while he played live at a Davis, CA, music store. I sat looking up at him for a more interesting angle, and wasn't feeling confident at sketching faces, so I let his violin obscure it. I had attempted to draw the singer, Rita Hosking, but changed my mind. You can still make out her face amid the sketch — appropriate given Andy was playing to the sound of her voice.

Above right **Pete Scully, *Chess players*, 2016.**

These two young men were playing chess at the Davis, CA, Farmer's Market. Without the addition of the chess board, and of the market details behind, it would not be as clear what these fellows were doing.

Right **Kumi Matsukawa, *Mexico en la piel*, 2014.**

Japanese urban sketcher Kumi Matsukawa sketched this dance group at a Cinqo de Mayo festival in Tokyo, Japan. Many Latin musicians and dancers performed and a camera crew was filming the scene, so Kumi included them, too.

Right **Pete Scully, *Dance Dance Davis, CA*, 2012.**

These locals took part in a community-driven dance event called Dance Dance Davis, organized by local performance artists and culminating in a huge dancing flashmob in Davis's Central Park. I was invited to sketch the rehearsals and the event. The simple moves and gestures were easy to learn, and so when sketching it was not hard to hook onto repetitive moves. Capturing the dancers' smiles was very important. Sketching to the music also helped!

Below **Kumi Matsukawa, *Dancing*, 2012.**

At a Christmas party held by a Spanish language school in Tokyo, Japan, some guest belly dancers performed a dance. Kumi Matsukawa used swift watercolor strokes to capture a hint of gesture: a dancer standing on one leg with a sword on her head, others caught mid-pose, a more colorful couple dancing close together.

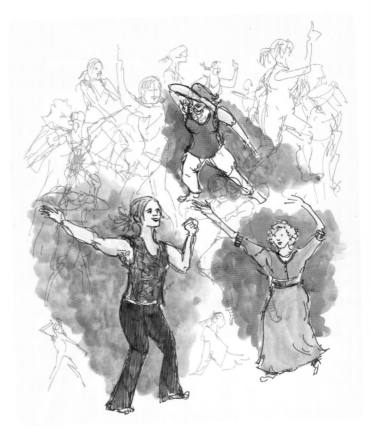

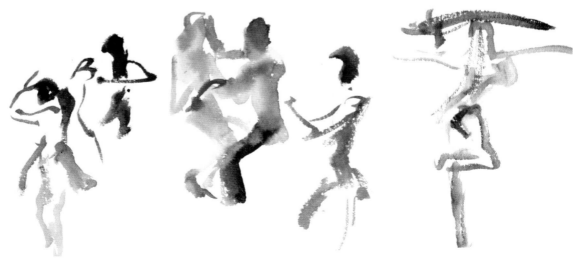

Capture motion: dance

Dancers show off the human form at its most expressive, and therefore make for interesting subjects to sketch. They can also be the most frustrating, and capturing the beauty of their movement and shape can be a daunting challenge for the casual sketcher, testing your observation and memory skills. They key is to loosen up, and allow your sketch to dance, too!

Tips to get you started

1 **Start with stick figures** Drawing a series of very quick stick figures, just a few seconds for each one, will help you identify all the different aspects of the dancers' movements. Be as observant as you can — maybe even draw without looking at the page. These will be a motion memory guide for a slightly more detailed sketch that you can follow up with.

2 **Move to the music** Dancers dance to music, so let yourself get in step and sketch to the rhythm. Perhaps let your pen or pencil move about the page to the music, like an athlete warming up before a race, and then dive into sketching the dancers. Allow yourself to move, to smile. The more relaxed you are, the more fun your sketch will be.

3 **Use artistic license** You aren't going to create a photographic tableau, and you shouldn't try to; one of the advantages of sketching over photography is its ability to tell more of the story all at once. If sketching a group, the dancers on one side may well be dancing to a different song by the time you get to them, but this all adds to the story.

4 **Loosen up those lines** You can create the illusion of motion with loose and overlapping lines. They don't even need to represent the dancers themselves, rather the train of their movement. Try sketching in a faster medium such as pencil or directly with watercolor paint. Allow outlines to be fluid, and add in any "non-changing" details, such as patterns on a skirt, after the loose form is drawn.

5 **Gestures and expressions** Look out for different hand gestures, especially if sketching a performing dancer, as these are important to dancers who express with their whole bodies, not just moving the torso as partygoers do. Include fingers on those hands, and be mindful of how dancers shape their feet. Include some facial expressions — sketching even a tiny smile can change the whole mood of a sketch.

Capture motion: sports

Another activity where you can sketch people in motion is sports, but it requires a different approach. It means more athletic postures, less rhythm, but more opportunity to practice quick dynamic sketches. It also means embracing the unknown; you'll never sketch the exact moment the winning goal is scored, but you can capture the movement and excitement of the occasion.

Tips to get you started

1 **Look for repetitive hooks** When sketching any sportspeople, remember that they will usually go back to certain poses. If trying to capture motion, avoid drawing their "easier" still moments (such as a tennis player waiting for an opponent to serve) and focus instead on their dynamic poses (such as reaching to hit the ball). Use additional loose lines to show the passage of their movement, or of the ball. You might want to draw a few stick figures to practice those poses.

2 **Sketch team motion** If drawing a team sport such as soccer or hockey, focus on how each team moves about the field. Are they spreading apart or moving as one unit? An attacking team's players will express a forward motion, while a defending team will generally have more taut and even slightly hunched figures.

3 **Watching on TV** You don't need to watch sports in person to sketch their motion, but if you do watch on TV, avoid the temptation to pause the game to sketch a still frame! Television allows you to sketch sports from a

variety of angles, and provides an opportunity to sketch from an elevated vantage point. Players appear smaller and less detailed, and so are easier to render with minimal strokes.

4 **Showing the color** Adding color is half the fun when sketching sports. It also helps distinguish one team from another. Using a little watercolor is good, but consider scribbling in the color with colored pencils as you go long. You might even draw one set of players in a different color pen than the opposing team — particularly fun in sports where players crowd together more, like basketball or football.

5 **Simplify the face** Facial details are less important when sketching people playing sports, as most players wear a neutral expression; the shape their body makes is usually more interesting. Adding a couple of quick strokes is often all you need. However, the direction a player is facing is key to showing their involvement in the action.

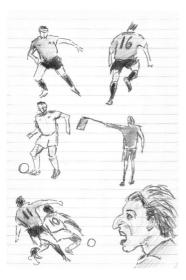

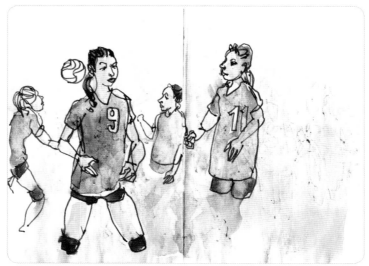

Above **Pete Scully,**
Uruguay vs. France, 2010.
Sketching sports from live television is a special challenge — the camera moves away from any shot before you have time to register it — but it's good practice when learning to sketch super fast. It does allow you to see a close-up of players' faces.

Above right **Rolf Schroeter,**
Volleyball, 2016.
These volleyball players were warming up for a match. Sketching action scenes requires making split-second snapshots in your mind as you watch them; it may not be as immediate as taking photos, but you can often illustrate more of a scene's important elements with quick pen and wash than with a camera.

Right **Marlene Lee,**
Soccer players, 2009.
When Marlene Lee's sons played soccer, she had many opportunities to practice sketching them. Here are two young players deftly captured at the moment of running, their bodies slightly tilted toward their direction.

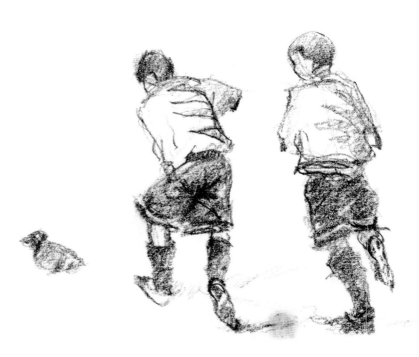

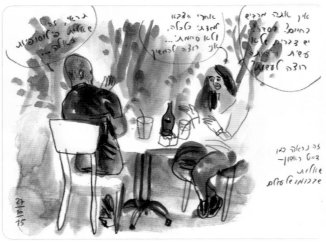

Above **Marina Grechanik,**
First date, **2015.**
The body language in this sketch by
Israeli artist Marina Grechanik shows
a conversation in itself, as two young
people enjoy a first date, but the addition
of speech (in Hebrew) adds extra flavor
to the air around them.

Above right **Pete Scully, *David Spight
at UCDAAC*, 2016.**
I sketched David Spight, the keynote
speaker at the 2016 University of
California, Davis Academic Advising
Conference, a few times, capturing him
here talking to a smaller group in a Q&A
session. One of his outstanding phrases
was, "You have to continue to keep
getting better at what you do — keep on
learning." I included that in the sketch.

Right **Pete Scully,**
James Housefield, **2014.**
Professor Housefield was giving a brief,
10-minute "TED talk" about design at
the breakfast session of a conference at
University of California, Davis, and I
wrote down some choice phrases as he
said them. I added some watercolor paint
at the end.

Include speech

People like to talk, and including a few words of speech in a sketch can add another level of personality and information that a quick drawing may not be able to convey. There are, of course, pitfalls — it's easy to misquote someone or distract from the sketch — but there are times when a few illustrative words will go a long way.

Tips to get you started

1 **Public speakers** When sketching a public speaker or someone giving a lecture, including key phrases that they use is a good way to document their talk. Adding these as they say them is the easy way to do it, but be mindful that the phrase you scribble down actually reflects their talk; one line out of context may distort their meaning and they will not appreciate being misrepresented.

2 **Keep it brief!** Since time is a factor, you won't be able to write out whole speeches, so be selective. Perhaps remember a few key words (or jot them down) and add them once your sketch is done. Again, remember to be careful not to choose words that misrepresent your subject's intentions.

3 **Overheard conversations** The urban sketcher is an observer, and occasionally overheard conversations pique our interest, so a few words can illustrate what your subjects might be talking about. Take care to respect privacy and not include anything particularly personal or potentially damaging to your subject. Safe subjects like the weather are usually fine!

4 **Handwriting style** Writing while doing a five-minute sketch means your handwriting will be at its loosest and least legible. If including speech you have to decide if you are OK with that, or if you want people to be able to read it. Remember that using all capitals looks like something is being yelled, while smaller writing or parentheses can mean something was just an aside, so tailor your handwriting to the speech patterns you are illustrating.

5 **Speech balloons** Adding quick speech is often done in a haphazard and disorganized way, but you can use speech balloons to give it a more cohesive look. This is better if adding the words after you have finished the sketch, and also links the words directly to the speaker. If you are brave you might use thought bubbles, adding words to describe what you think a person might be thinking about. This can be a fun game when sketching strangers on public transport — as long as they aren't too offended if they see what you write!

Capture conversation

When drawing two or more people talking, an easy way to indicate conversation might be to add speech bubbles, but it's usually more interesting to show people conversing. In real life we may not be able to hear (or understand) what people are saying, but there are ways to show that they are interacting with one another — their body language, posture and facial expressions. Capturing a conversation wordlessly means we can imagine what they might have been saying, which is much more fun!

Tips to get you started

1 **Body language** When people talk in a public place, they usually lean in toward one another so they can be heard. Their hands may be making gestures as they speak, which in a way draws the other person in. The body language of a conversation will usually be positive and engaged, but focused on the person the participants are conversing with, rather than the world at large.

2 **Eye contact** When drawing people in conversation, you might find that they are not actually staring at each other the whole time, but showing them making eye contact portrays the idea of connection. Watch the eyes of the person listening; they might not look directly at the other person's eyes, but will usually be looking in the direction of the speaker.

3 **Facial expression** While the eyes make the connection, the mouth tells us a person is speaking. It seems obvious, but draw the mouth open if someone is talking — and that means

showing space beneath the top teeth; this isn't just a smile. Often the eyebrows are raised slightly when talking. Faces that are talking are usually more expressive.

4 **Focus on the listener** The body language and expression of the listener is also important. Are they drawn toward the person speaking? Perhaps they are gesturing in agreement or otherwise. Often a person will lean on their hand with a neutral look — or perhaps pretend to listen while looking at their cell phone!

5 **Draw several speakers** A conversation is an active position, so make it appear more lively by drawing all the people speaking simultaneously! Draw the same person in different poses to show different stages of the conversation. This is more fun if you are in a place where people will be more animated when they talk, such as around young children.

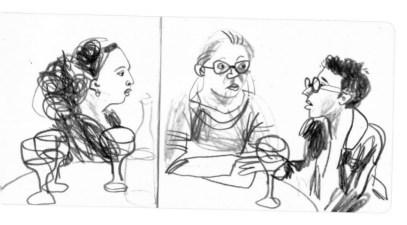

Left Marina Grechanik, _Three friends_, 2012.
In this sketch, urban sketcher Marina captures three friends engaged in serious conversation over wine. The eye contact and expressions of the two people not speaking show they are listening intently, while the speaker uses hand gestures to elaborate.

Below Pete Scully, _Sue and Kumi_, 2013.
This sketch shows two fellow urban sketchers in Barcelona, Spain, in conversation, though not with each other — the other people are "off-screen." Nevertheless, it is clear that they are conversing. Sometimes you only need to show part of something and the mind will fill in the gaps.

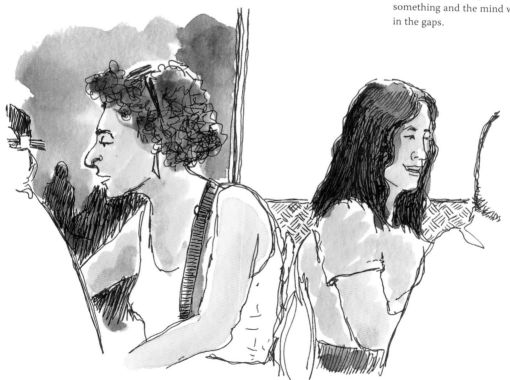

Above **Cathy Gatland,**
Newtown figures, 2013.
Cathy Gatland sat in one spot in a busy square in Johannesburg, South Africa, and sketched the variety of people walking past, trying to capture the bustling movement and interesting shapes of their clothes and the baggage they carried.

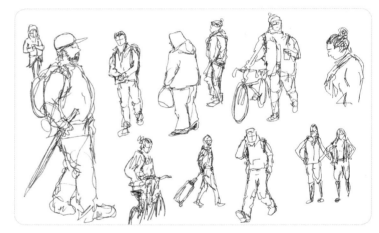

Above and left **Pete Scully,**
Passers-by at University of California, Davis, 2016.
I stood nearby the Silo Bus Terminal at University of California, Davis and sketched students as they hurried by. It was a cold day, and there were lots of jackets and backpacks. Being in a bus terminal, people moved quickly to get where they needed to be. I had to be very quick, and relied on watching repetitive poses.

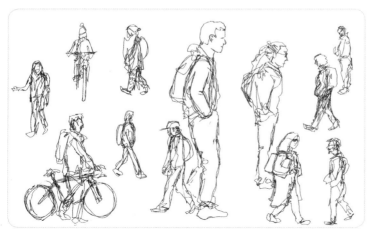

Catch the passers-by

Imagine you are people-watching outside a café. You want to sketch the world as it passes down the street, but those people just walk too fast for you to draw them. You may only have a few seconds to observe them. So how do you do it?

Tips to get you started

1 **Rely on your memory** Drawing what you see is all very well, but when what you see moves away too quickly for you to finish a sketch you have to remember what you saw. Whenever you look at your page while sketching, you are in fact sketching from memory, even if looking back up every few seconds, so it's worth honing your observation skills and taking pictures in your mind.

2 **Don't look at the page** Another way is to try sketching "blind contour" — that is, watch your subject and draw without actually looking at the paper. The results may be rather interesting at first, but after a while your sense of proportion will become more instinctive. This technique cuts down the time it takes to sketch someone!

3 **Have a toolbox of body shapes** Practice sketching different body shapes, so when you are trying to draw passers-by you can add them in quickly. Perhaps someone is pushing a stroller — practice that, too. Another good pose to practice is the cyclist; if you live in a town full of cyclists you'll want to add them in, but they go by even faster!

4 **Walking poses** If your passers-by really are passing by, show the action by drawing their legs in realistic walking poses. Watch the shape of the feet as they lift from the ground. Try to draw the legs in full stride to portray walking more effectively. Again, this is something you might want to practice; you won't have too long to observe each individual's walking style.

5 **Mix and match!** Nobody is going to check that every passer-by you have sketched is completely accurate. If you're sketching a tall man with a beard, but he is gone before you have finished his body, just draw some of the next tall man. Don't make things up — you are representing the people in general. The people attending a baseball game will not necessarily look like the people passing by at the opera, for example.

Crowds made easy

Drawing one person can be daunting enough. Drawing a crowd takes courage!
How do you capture so many people in a short amount of time? Everyone looks
different, they may be moving in different directions and you still want to
make them look like actual people and not a large scribble of egg shapes.
Sometimes, however, five minutes is all you need to capture a crowd!

Tips to get you started

1 **Start at the front** Draw the people at the front of the crowd, just the basic shapes at first, starting with quick downward strokes for the legs and then the bodies and heads. Then, for the figures behind, you will probably only need to focus on the heads. Keep it simple — just basic head shapes. Make the lines looser as you go farther back. Add some quick detail to the figures at the front. Don't make your people shapes too generic; try to represent the type of people you're actually seeing.

2 **Focus on the whole** You can get lost in a crowd, but if you see it as a single shape, it makes it easier to conceive. Try sketching the rough outline of the crowd and adding a few details, or sketch the whole crowd without lifting your pen from the paper. It will lead to fun results!

3 **Keep it in perspective** Are you standing at the same level as the people in the front of the crowd? You won't see a lot of heads rising behind your front characters unless you yourself are in an elevated position. Most people are an average height, so the heads in a crowd act as a natural horizon line. The closer you are to the crowd, even if the heads remain at the same level, the feet of every figure will start getting closer and closer to the vanishing point. Detail can also suggest perspective — those at the front can be more detailed than those farther back.

4 **Movement and direction** If your crowd is watching an event they will likely be pretty still, with heads facing in the same direction. If in a bustling town square, however, those people will be flowing all over the place. Even in the quickest of sketches you can show movement by adding some lines of direction along which your figures might be moving. Drawing legs in a "walking" pose does a lot to suggest motion.

5 **Color the crowd** Some crowds, such as at sports games or rallies, will often have a main set of colors you can use to create the general crowd sketch. Alternatively, lay down an area of color roughly the size of your crowd and sketch in some people details over it. If someone in the crowd stands out, color them in and leave the rest uncolored.

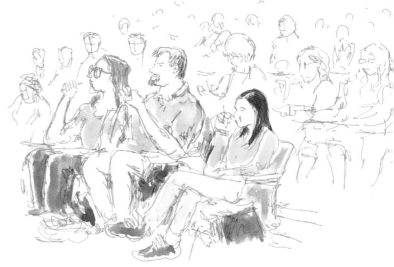

Right **Pete Scully, *Design class University of California, Davis*, 2016.**
I was invited to sketch the speakers at a design class on campus, and managed to do a few sketches of the very sizeable crowd seated in the auditorium. As a five-minute sketch, details had to be few, and I used a pink pen to make it brighter. A few quick marks give the impression of a seated crowd sloping upward.

Left **Kumi Matsukawa, *Asakusa Sanja Matsuri*, 2014.**
Asakusa Sanja Matsuri is one of the most famous festivals held in Tokyo, Japan. People were putting on happi coats and headbands, or carrying portable shrines, and their chorus of chanting gave the scene excitement and a very Japanese ambience. Kumi sketched them using brush pen and watercolor.

Right **Pete Scully, *Starbucks, Davis, CA*, 2016.**
While watching a group of people lining up at Starbucks in Davis, CA, I decided to do a quick sketch of the whole group as a single-line sketch, not taking my brown Micron pen off the paper the whole time. The line of people moved slowly, but my line moved very quickly — this technique is a useful way to handle large groups of people.

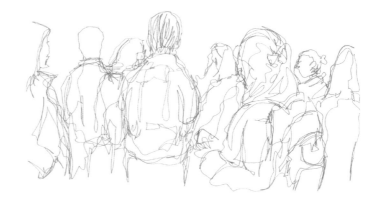

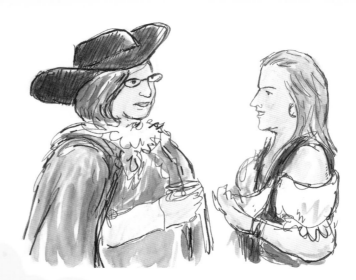

Above **Pete Scully, *Kalina and Angela*, 2015.**
At the Swashbuckler's Ball in Portland, OR, we all dressed in a piratical fashion. Here is my wife Angela and friend Kalina chatting over the pirate music. I let a few strokes of paint show the folds in the material.

Left **Pete Scully, *Shopper at the market*, 2016.**
This lady was bundled up on a brisk morning at the Farmer's Market in Davis. With only moments to sketch her as she stopped, I captured the warm jacket with minimal fold lines at the elbow, but focused more on the very ruffled scarf and the red shoulder bag. Her posture holds it all together.

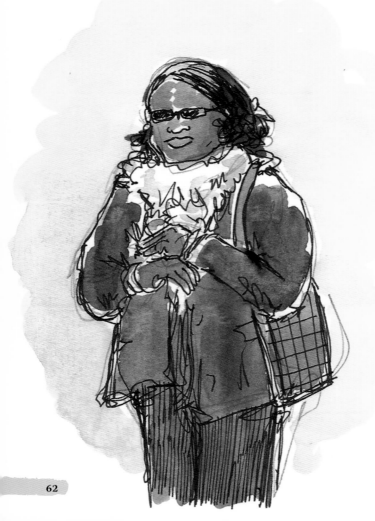

Clothes done quick

When sketching people, for the most part what you are really sketching is their clothes. These are usually an afterthought when compared to sketching the frame of the body, but it's important to observe how the clothes really look — the textures, the folds, the way the light reflects from them — so don't forget: clothes maketh the sketch!

Tips to get you started

1 **Fast folds** Observing where the folds are in clothing can make a big difference. Look at how shirts crease a lot at the elbow, or how pants bunch up at the ankle. A few zigzagged lines can imply creasing. Remember, if a body part is bent, it is the inside of the bend that shows creased clothing. Skirts and dresses have slightly more complicated folds; focus on the flow of the fabric, and watch how they tend to open up as they drop.

2 **Hats and accessories** When sketching hats, always envisage the shape of the head beneath. Baseball caps curve in an interesting way, and will create shade beneath the rim. Scarves can be fun to draw, but don't overdo the sections that fold over. Backpacks and handbags become almost like extra appendages — with heavier bags, make sure the person's posture slumps accordingly!

3 **Texture** Some clothes, such as wooly sweaters, have wonderful textures, which can be reproduced with quick scribbling. These scribbles can also indicate any folds in the material. For shinier textures, such as polyester,

a minimum of detailing is needed, though if coloring in you'll want to show the reflection of light on the material by leaving areas (usually those in the upper body, like the shoulders).

4 **Simplify** Don't get lost in the clothing — simplification is the key. There will be lots of shading on the folds of clothing but sometimes just a few strokes is all that is needed. Practice at home by looking at your own clothes, or the folds in the curtains, and break them down to their simplest lines.

5 **Colors and patterns** If someone is wearing simple colors, these will be reasonably straightforward, but observe how the light reflects on them — some areas may appear much paler. If someone is wearing a pattern, you may not have time to fully recreate that in a quick sketch, so try doing just a few small parts. You can always finish it off later, or leave it blank — the mind will fill in the gaps!

Focus on the emotion

If you are sketching people on location, a display of emotion, however subtle, can make your sketches so much more attractive than those featuring people with serious, neutral expressions. Showing how people are feeling adds a level of story to the sketch, rather than being simply an observation of form. Opportunities to capture different emotions in a live sketch can be limited, so sometimes it comes down to your own observation skills.

Tips to get you started

1 **Facial expressions** The face is usually key to expressing emotion, but you only need to pay attention to the eyes and mouth. The eyes themselves tend to narrow or widen, but the true expression is with the eyebrows; raised eyebrows can mean shock or surprise, while downturned eyebrows usually stand for anger, although they can also be used for laughter. Don't rely too much on the usual tropes — watch your subject's expression and draw that.

2 **Gestures** Emotions are not limited to facial expressions — gesture and posture are important indicators of how someone is feeling. Be mindful of the gestures you draw; some can be misinterpreted depending on the culture. Extreme emotions like anger and elation can be treated with more expression. Watch the body language; angry people will clench up or hunch their shoulders, while sad people may slouch.

3 **Visit emotional places** Try sketching at places where people are more likely to display exaggerated emotion, such as a big sports event, where people will be cheering, singing or occasionally frustrated and angry. Sketching at a funeral may not feel very appropriate, but public memorials are places to observe solemn emotions. If at more "emotionally neutral" places like the market or a café, try to capture simpler feelings, such as quiet frustration or pleasant surprise.

4 **Feel free to scribble** Another way to express emotions is to sketch more abstractly. Use scribbling techniques to draw gestures. Use warm color tones for the more passionate emotions, and cooler tones for the opposite. Try sketching just the facial expressions without the body, repeating the eyes and mouth over and over as you observe.

5 **Avoid being too cartoony** It can be hard to convey particular emotions with subtlety in a sketch, but unless you are actually drawing cartoons or caricatures, it's important not to draw physically impossible expressions. Keep it realistic; maintain the integrity of your drawing.

Right **Pete Scully**, *Irina*, **2016.**
In this sketch, Irina has a friendly smile while she converses with a colleague at a party. The relaxed emotion is shown not only in the expression on her face, but also in her body language — the hand placed under the face.

Below **Patrizia Torres**, *Jazz musicians*, **2015.**
In this sketch of jazz musicians by Patrizia Torres, the different poses, the splashes of color, the expression of joy on the singer's face combine to make this a happy ensemble.

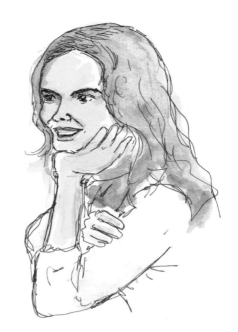

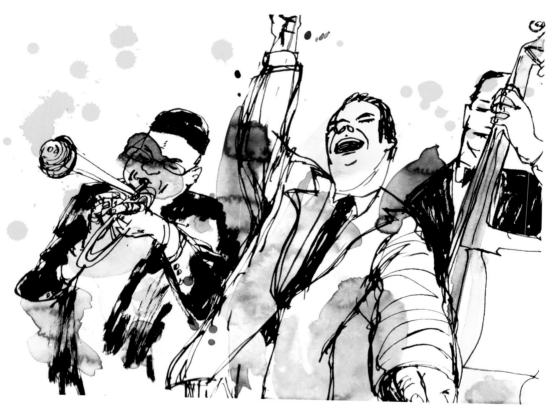

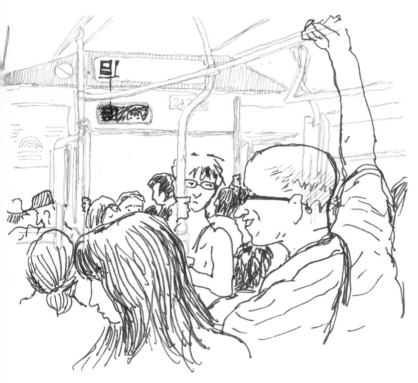

Above **Don Colley**, *Untitled #1*, **2016.** Here, Don Colley uses markers to catch the classic commuter pose, looking at a digital device, wrapped in a warm jacket.

Left **Pete Scully**, ***BCN bus to Guell***, **2013.** Standing on a crowded bus full of tourists in Barcelona, Spain, on the way to Park Guell, I sketched the passengers as quickly as I could, and added the details of the bus in a different color. I ended up talking to the man and woman in the foreground, a couple visiting from Sweden.

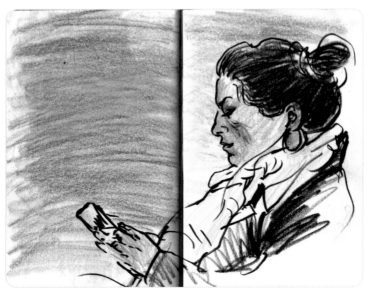

Left **Kalina Wilson**, ***Commuter***, **2013.** I sometimes wonder what people used to do on the bus without phones and tablets to look at! Kalina Wilson sketches her fellow Portland commuters, and here she took a snapshot of a woman in profile engrossed in her phone, using ink and colored pencil. The digital device has replaced the newspaper as a way to avoid the world around you on public transport; sketching, however, does the opposite, and gives you a great many unwitting subjects!

Sketch commuters

For many of those who travel by public transport every day, that time seated on the bus or train is often a great moment to read a book, do a crossword — or even sketch! You are surrounded by potential models to practice drawing, and you have to be quick, and often stealthy. If you can get the hang of sketching on crowded public transport with the bumpy motion making your lines jump across the page, you can probably sketch anywhere.

Tips to get you started

1 **Draw the person ahead of you** On the subway or train there might be someone sitting directly ahead of you. Usually people are lost in worlds of their own and so easier to sketch, especially those who have nodded off! You'll need to hone that quick sketch technique, but if you know how much time there is between each stop, then you have a window of at least that long.

2 **Sketch aspects of the crowd** In a crowded space your subjects may blend into one another, but you aren't really trying to capture recognizable people. Try drawing the crowd in a loose fashion; look for simple shapes that stand out, such as arms aloft grasping supports, newspapers being held up, the legs of people obscured by other passengers.

3 **Use stealth** Most people mind their own business on public transport, so if someone is obviously staring and sketching others, it may make people feel uncomfortable. Use discretion, and mind your body language. Avoid staring; maybe look in other directions

occasionally, and if someone does notice you sketching them, be open and pleasant. Most people are usually fine with it. For those who aren't, just remember that buses and trains are public spaces.

4 **Backs of the heads** A lot of the time you will be looking at the backs of people's heads, especially when sat on the bus, but those views aren't always boring! It is a good opportunity to practice sketching hair, or the shape of the ear.

5 **Go with the line** You aren't always going to have a steady hand sketching on the bus or train, so use that to your advantage. The lack of control will loosen up your lines and encourage more expression and mood with less focus on detail. Try drawing without lifting the pen from the page, and see where it takes you.

Drawing children

Drawing children from observation could be a whole book on its own! They move differently, express themselves differently and have totally different proportions to those of a typical adult. They change so much as they grow, too — drawing a child of 10 is not the same as drawing a child of 15 or five.

Tips to get you started

1 **Proportions** Kids aren't simply small adults; they have very different proportions and it's easy to forget that. A young child's head will usually be large in proportion to their body, but also not elongated like an adult head. The torso will be smaller in proportion, no more than two "heads" long, but with fewer distinct curves. Legs and arms are shorter, but often relatively thicker. Note that the sole of an infant's foot is flat, not arched like an older child or grown-up.

2 **Faces** While children's heads are smaller than adults', certain features will not be. The eyes do not grow much as a child gets older, so an infant's eyes will appear slightly bigger on their face. Also unlike adults, their eyes are not quite halfway up the face; the distance between eyes, nose, mouth and chin is smaller in children. Noses are smaller, and tend to point up more. Be softer with the features, and keep facial lines to a minimum, even if they are laughing.

3 **They move quickly!** Sketching children can be the ultimate exercise in quick observation. Try to look for the poses they make the most, but keep it loose. Try to represent their energy — kids have a lot more of it than grown-ups! Sometimes the easiest time to sketch a child is when they are watching television, eating dinner or when relatively still, such as when painting. A sleeping baby is even easier to draw, but don't wake them up! And if you can't get them to sit still, sketch their toys or their shoes.

4 **Personality** Children are likely to be more expressive than adults, so let their personality into the sketch. Add a few words that they might be saying, and don't forget to include their hand gestures. Expression can be found in more than the eyes and mouth, but in posture, too; even shy kids carry a lot of expression in their body language. Messy hair, sticky faces and muddy feet can also reflect a child's carefree attitude.

5 **Permission** If you are sketching in public, take care when sketching children that their parents do not mind. It's good to ask for permission first if you can, especially when drawing specific portraits, or at least show the parents once you are done and let them take a picture of it. Most people cannot resist a sketch of their daughter, son or grandkid. If possible, encourage the child to draw you, as well!

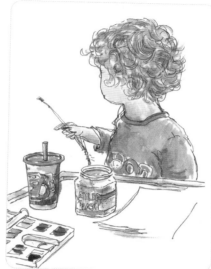

Left **Pete Scully,**
Luke aged three, 2011.
My son was home from
daycare with a cold, so to
keep busy we did some
painting. However, his
attention was being drawn
to *Fireman Sam* on the TV,
so I sketched mostly wild
hair, but also his little hand
holding a long paintbrush.

Above **Pete Scully,**
Luke aged two, 2010.
This sketch of my then-two-year-old
son Luke was made very quickly
while he sat watching something on
television — probably *Elmo's World*
— after getting his hair cut. He didn't
stay still for long!

Right **Patrizia Torres,** *Malabo
preschoolers*, 2013.
Patrizia visited Virgen del Carmen
School, in Malabo, Equatorial
Guinea, with a non-government
organization. "When we entered into
the classroom, all the four- and
five-year-old schoolers started to sing
a song as a joyful welcome."

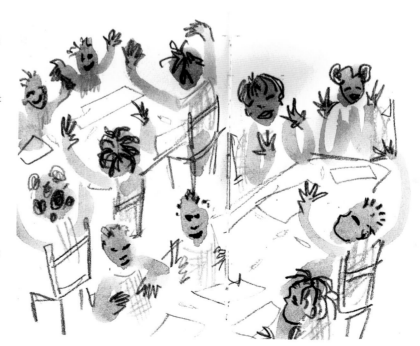

Right **Pete Scully,**
Man at the Bar, 2016.
I sketched this very interesting
gentleman at Pete's Tavern in New
York City, NY. To show age, I included
subtle lines at the eyes and on the
cheeks. For the gray hair, I kept lines
to a minimum and used a little blue
to show the darker areas.

Below **Marlene Lee,**
Woman at nursing home, 2011.
Marlene says: "My mother had to
spend some days in a nursing facility.
Her roommate was an elderly woman.
I caught her in this sketch when her
lunch was just delivered to her."

Showing age

Age can be a complicated thing to sketch. Some people prefer not to be shown how many gray hairs they have, or the number of lines around the eyes, and it is easy to misrepresent someone's age in a quick sketch. Everyone ages differently, but it's worth knowing a few tricks to help you get you close.

Tips to get you started

1 **Facial lines** In younger faces the lines are often softer or not really pronounced, whereas in older faces those lines will be clearer. This doesn't just mean wrinkles around the eyes, but also smile lines, creases on the forehead, even cheek bones. A couple of little downward-pointing lines below the edge of the mouth commonly suggest age. The eyes show age the most, with heavier eyelids and deeper bags. Be selective about how you draw lines around the eyes; even just a couple of "crow's feet" at the edge can suggest advanced age without overdoing it.

2 **Age in the body** Obviously everyone is different, but as people get older, it is not uncommon for certain areas of the body to get fuller, such as the waist or the neck. Arms and legs will start showing more wrinkles at the elbow and knee. Posture changes with age, too; while a youth may be upright and full of energy, an older person might stoop a little more. Observe the basic busy shapes of young and old people by drawing stick figures of them, and compare their poses.

3 **Hair** The most obvious signs of age in hair are graying and thinning locks. If your subject has gray streaks in otherwise dark hair, leave those parts mostly blank if sketching in pen or pencil; they will stand out more against the darker hair. For receding hairlines, just remember the overall structure of the head. The more marks you add, the thicker the hair will look.

4 **Draw generations** If you have a chance to sketch two or more generations of the same family — a daughter, mother and grandmother, for example — you can show three different ages in one go. This way you can compare one to the other. What in the sketch makes the mother younger than the grandmother?

5 **Be honest** Some artists prefer to draw people as they really are; don't be afraid to be unflattering. When sketching people of a certain age, they will always ask you to make them look younger, but when drawing from life, it will always make for a more realistic approach if you draw your subjects warts and all.

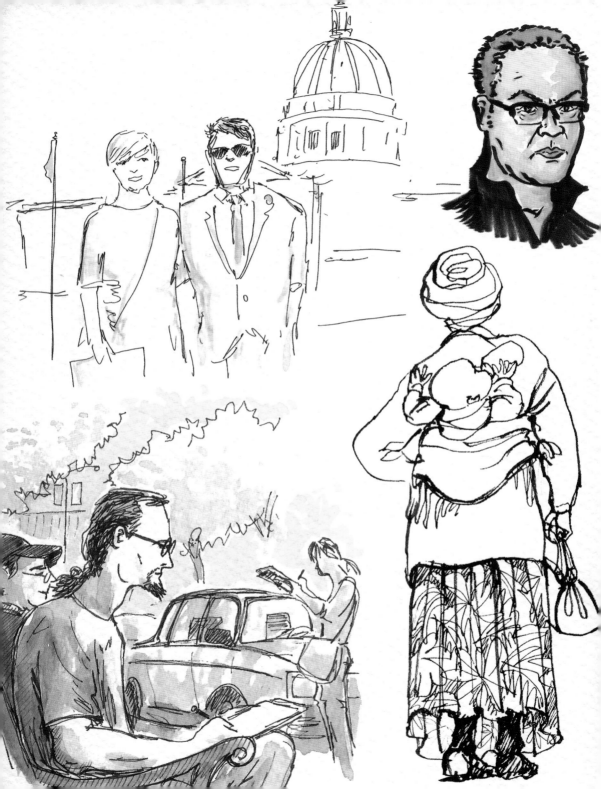

Time-saving techniques

How you draw is entirely personal, but it's worth trying out a number of different techniques to see not only which ones you like best, but also will save you the most time. When you only have a few minutes here and there to sketch, choosing an uncomplicated style you can jump into quickly opens up a whole world of sketching. How can you get the most out of just a few strokes of the pen? When should you use thick lines or loose lines, or simply start scribbling? What are the easiest ways to show light and shade? What exactly are "contours" and "tonal values"? It's worth wandering outside of your comfort zone, and trying styles you might not have considered. When you start to play around with various techniques, and discover which work best for you, your sketches will begin to go in new and often unexpected directions.

Left Here are different quick sketching techniques: thick, quick, loose, and tight lines, contours, hatching, shading; try a few different styles!

Use minimal lines

Sketching when you have no time often means not getting as much done as you'd like. Each line of the pen, each stroke of the brush, they all take up precious minutes, so sometimes it pays to be more frugal with your line work. Embrace the idea that "less is more."

Tips to get you started

1 **Draw quick outlines** Merely focusing on the outline and leaving the details out may make it hard to identify your subject, but you can have fun capturing different personality traits by sketching just the person's outline. Do they slouch? Do they wave their arms when they talk? A quick outline can tell us a lot!

2 **Swift, short strokes** Some of the most effective sketches can be made with just a series of short strokes. Using a fine pen or pencil can be effective with this type of sketch. Try not to draw an enclosed outline, but draw unconnected lines that suggest the whole. Whatever details are left out can be filled in with the mind; our minds are good at that!

3 **Focus on gesture** Draw the shape of the gesture, rather than focusing on the details. It need not be an exciting gesture, such as someone hailing a cab or dancing; a simple gesture, such as sitting in thought with a hand beneath the chin, can look effective with just a few well-placed lines.

4 **Simple faces** Focus just on the face itself, on the expression. Perhaps sketch the hairline shape to border the face, without drawing the whole head. The expression will all be in the eyes and the mouth. Keep the eyes simple — merely the top eyelid, the pupil, and maybe a quick stoke for the eyebrow. Add the shape of the end of the nose or even just the nostrils and then draw the mouth in one or two strokes. Remember, less is more; unnecessary lines can disrupt a sketch's simplicity.

5 **Try using a thicker pen** A heavy-sized nib (such as 08 Micron) or a brush pen will force you to sketch with fewer lines. Those big, broad strokes can be great for capturing dynamic figures with a couple of lines. Avoid the temptation to add too much shading with the brush pen, and go for quick lines instead.

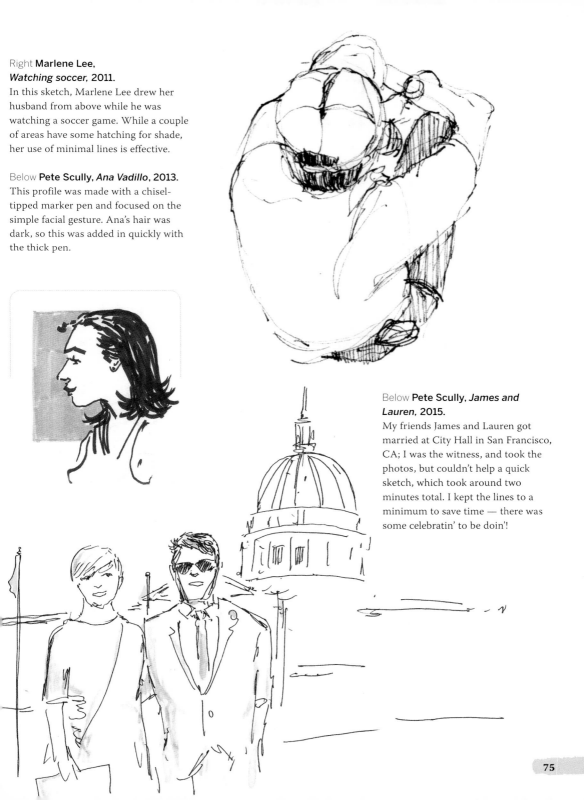

Right **Marlene Lee,**
Watching soccer, 2011.
In this sketch, Marlene Lee drew her husband from above while he was watching a soccer game. While a couple of areas have some hatching for shade, her use of minimal lines is effective.

Below **Pete Scully,** *Ana Vadillo*, 2013.
This profile was made with a chisel-tipped marker pen and focused on the simple facial gesture. Ana's hair was dark, so this was added in quickly with the thick pen.

Below **Pete Scully,** *James and Lauren*, 2015.
My friends James and Lauren got married at City Hall in San Francisco, CA; I was the witness, and took the photos, but couldn't help a quick sketch, which took around two minutes total. I kept the lines to a minimum to save time — there was some celebratin' to be doin'!

Fast and loose lines

Drawing quickly often means we don't have time for tight, labored pictures, so developing a faster and looser style can be liberating. You might focus on quick outlines, gestures; don't worry about details or faces. It takes practice though — drawing loose is not the same as drawing sloppy.

Tips to get you started

1 **Break out different materials** Try using a "fast" medium that you are less familiar with. If you normally draw with pen, try drawing directly with paint, or with oil pastel. Be careful not to use materials that will deliberately slow you down, though — the trick is to speed up by not falling back on usual routines or techniques. Being out of your comfort zone will help you develop a looser approach.

2 **Draw with your arm** Yes, your arm! Most people sketching in sketchbooks will naturally draw only by moving their wrist, resulting in tighter sketches, but let loose by drawing from the elbow or even the shoulder. You may need to hold your sketchbook up, or get a bigger piece of paper, but that sense of control you lose will get you looser lines. Try it!

3 **Draw with a single line** Instead of a series of quick and loose strokes, try placing your pencil on the paper and sketching with one long continuous line, taking in as many details in your sketch as possible. This is especially fun with portraits. Don't worry about accuracy, just follow the line and see where it takes you.

4 **Feel free to exaggerate** Even when drawing from life, you can still have a little fun with your sketches. Stretch out those poses, make those legs a little longer, add a little rotundity, puff up that hair; using looser lines can give you the creative license to exaggerate people a little, without making them caricatures or cartoons.

5 **Don't overwork it** Adding too many details can overcomplicate a sketch and cause it to lose its freshness and spontaneity. Try to keep it simple. Keep practicing — sometimes what makes a "good" sketch is simply confidence. It takes effort to look effortless!

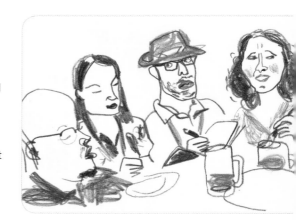

Below **Pete Scully**, *Gabi in Lisbon*, **2011.**
As the founder of Urban Sketchers, Gabi
Campanario did not stand still very often
at the second Urban Sketching
Symposium in Lisbon, Portugal, so I had
to be quick sketching him. The lines
were kept rapid and loose, using mostly
red but a little bit of green (for an
unexpected 3-D effect).

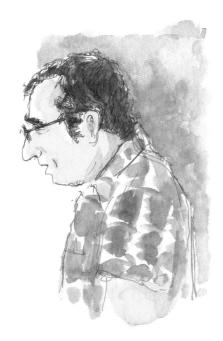

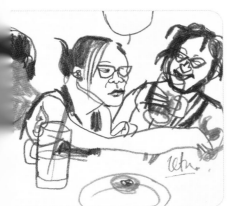

Left **Marina Grechanik,**
Singapore sketchers, **2015.**
Sketchers get together and sketch
each other, and at this meal in
Singapore, Malaysia, Marina
Grechanik used fast lines to
create loose but still remarkably
accurate sketches of everyone at
the table, all engaged in different
poses. The convivial conversation
can be felt in the style.

Above **Cathy Gatland,**
Hoedspruit Bakkie, **2015.**
In this image, Cathy Gatland's
experiences while sketching
seeped into the line work itself,
as she explains: "We were driving
behind this small truck for some
distance on a potholey road in a
rural area. I had the urge to
sketch it and had to scratch
around to find paper and a pen.
All the bumps and judders show
in the drawing; any attempt at
detail was abandoned."

Right **Cathy Gatland, *Sandton people*, 2015.**
In these images, Cathy Gatland used a clean line style to draw people from behind as they lined up to try a lucky dip in a chocolate promotion in this shopping center. Even the flowing shapes of the clothing are rendered in a very precise manner.

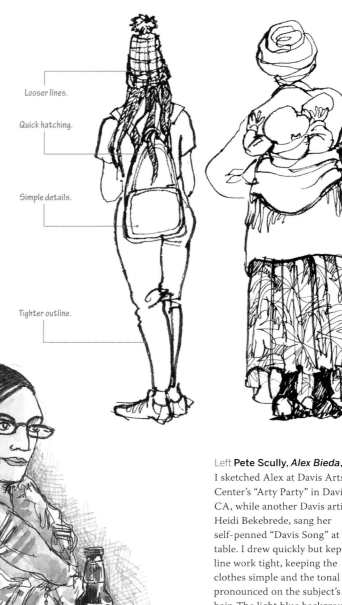

Looser lines.

Quick hatching.

Simple details.

Tighter outline.

Left **Pete Scully, *Alex Bieda*, 2012.**
I sketched Alex at Davis Arts Center's "Arty Party" in Davis, CA, while another Davis artist, Heidi Bekebrede, sang her self-penned "Davis Song" at our table. I drew quickly but kept the line work tight, keeping the clothes simple and the tonal values pronounced on the subject's dark hair. The light blue background was added to complement the color scheme.

Try tight lines

Loose lines can emphasize the quick nature of a five-minute sketch, but how can you save time and still draw something "tight" with relative accuracy and clarity? Tighter sketches need not look flat and one-dimensional, but can really stand out if done effectively.

Tips to get you started

1 **Start by drawing small** If going for a tight sketch, draw in a smaller scale, and take a bit more time with each stroke. Guide the lines gently, keep the details simple, focus on what is most important. A fineliner pen works best for this sort of sketch, but a fairly sharp pencil works well, too.

2 **Draw from the wrist** Hold your book close to you, and draw without moving your arm about, just your wrist. This literal tightness will likely help you to draw tighter lines. Always make sure you are comfortable though, and you will produce your best sketches.

3 **Thicken the outline** Start by drawing the outline of the person in clean, smooth lines and then add simple details such as the face or the clothing. Then go over the outline again to make the line thicker; this will serve to emphasize the thinner interior details. If you are including a background, the thick outline will help your people stand out.

4 **Combine "tight" and "loose"** The two don't have to be opposites — in fact with practice your tight lines may loosen up while still retaining their sense of accuracy. Think about drawing a fairly tight outline of a person, and fill with "looser" elements such as quick hatching, or scribbled shading using a colored pencil. This will help avoid a sketch looking too flat.

5 **What would Tintin do?** It's worth looking at comic books such as *Tintin* to see how simple, tight line work can be effective. Tintin's creator, Hergé, drew in what is called *ligne claire*, or "clear line," with lines of the same thickness and no hatching or shading, except with color. Proportions were realistic, not exaggerated. Practice observing some people and sketch them in this style — but no need to turn them into cartoons!

Left **Pete Scully,** *Selfie 29*, **2016.**
This quick self-portrait was drawn with a very thick Copic sketch marker. The thick outline helps define the image more than in similar thin-lined sketches I have done, creating a powerful effect. The thick black line also provides a nice contrast with the more gentle watercolor wash.

Above **Cathy Gatland,** *Umbrellas*, **2013.**
In the South African summer, the umbrellas come out in the streets as much to protect against the hot sun as against the rain. Cathy Gatland did a small series of women holding them — waiting at a taxi stand, crossing the road outside a café. The bold colors were added after, and complement the bold line work.

Try thick lines

A thick line can be very powerful, bringing to mind graphic and animated styles. What's more, for the five-minute sketcher a thick pen can draw much more quickly than a fineliner, allowing you to cover more ground in a short time. There are different ways of achieving thick lines, and it's worth playing with them to see if they will suit your style.

Tips to get you started

1 **Types of thick pen** There are different ways to get a thick line — using a bigger nib is the most obvious, but you can also create thicker lines by going back over your line several times. Brush pens are fun, and very expressive, but a little tricky for the beginner to get the hang of, especially if adding finer detail. Wedge-shaped nibs such as Copics or graphic pens can be good for really thick lines, while still being capable of thin strokes.

2 **Draw the outline** A thick outline can help distinguish people from one another or from the background, so go straight to drawing the thick outline! Drawing them as unbroken contours, almost as silhouettes, can be very effective and clean.

3 **Add thick lines at the end** Thick lines are good for emphasis, so when sketching with thinner pens or pencils, go over certain areas, such as the contours, afterward with a thick pen to make them stand out. This way they can complement the other lines.

4 **Creating thick lines from fine** When sketching with pencil or fine pen, you can create lines with heavier weight by going over them again several times. Pencil is especially suited to this type of line work, as you can create darker lines by adding pressure or by angling the tip.

5 **Be minimalist** Try to avoid making too many lines with a thick pen. A minimalistic approach will benefit the sketch, while overdoing it will make the whole sketch too crowded. Facial lines that are subtle when drawn with a fine pen are best left out when sketching with bolder lines.

Contour drawing

A quick but effective way of sketching people is by drawing what's known as the "contour" — in essence the outline — emphasizing the shape and volume while reducing detail. There are different ways to approach contours, and these can be great starting blocks or fun styles in themselves, but contour drawing is a useful skill for the quick people sketcher.

Tips to get you started

1 **Basic outline** Contour means outline, so start by simply sketching someone as a basic silhouette. You might practice by actually holding your pen up and drawing an imaginary line in the air around the person you want to draw, to help visualize the contour. Draw the line slowly and deliberately, taking care to think about the shape. It's hard to focus on just the outline, so try sketching it as a continuous unbroken line; it doesn't have to be perfect!

2 **Minimal line gestures** Some of the most effective contour drawings don't have a continuous line running around the figure; rather, there are broken segments of line that merely suggest the contour, letting the mind fill in the rest. Practice doing this by sketching a person just by the curves, such as the shoulder, the chin or maybe the gesture they are making with their hand.

3 **Blind contour** A fun game to play is when you put the pen on the paper and draw your subject without looking down at the page. This is called blind contour drawing, and is a good way to turn off your dependence on the page and trust your instincts — and the results can be surprising! Sketching blind contour helps take the "thinking" out of observation drawing by letting you just "do."

4 **Sketch a crowd's contour** Go somewhere where a good-sized group will be gathered and sketch the outline of the people as a single shape, watching carefully for the spaces between them, and the general shape of legs and feet as well as heads. Then sketch a few contours of individuals, to bring them out. Try sketching a group of individual contours and have them overlap, a trick that gives the impression of movement.

5 **Add a little detail!** It's a good skill to practice, but you don't need to stop at the contours. Try adding in some details here and there, more as suggestion than anything. Maybe draw interior details, such as faces or clothing, in a different color from the contour. Drawing the contour first means if you run out of time for the sketch, you have the main structure in place.

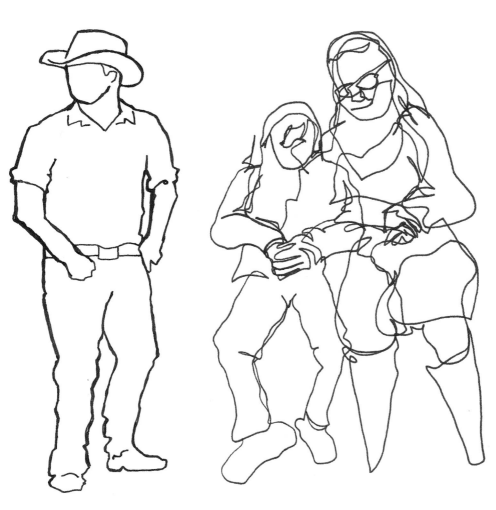

Above **Pete Scully,**
Cowboy contour, 2016.

In this sketch, just the general outline
has been drawn in a fairly deliberate
fashion, but with a few details showing
the edges of the figure's clothing. This is
just one way to approach contour
drawing; for a more "alive" feel, a quicker
and looser line is better.

Above **Pete Scully,** *Blind contour*, 2016.

Blind contour drawing means not
looking at the paper, but trying to draw
the outline or the general pose of the
figure, preferably without lifting the pen
from the paper, letting your hand move
as your eye does. It is not easy and often
produces interesting results. In this one
I have sketched a seated mother and
child, letting the lines overlap, adding a
little expression to their pose.

Right **Don Colley,**
Nick Sistler, **2014.**
In this sketch, Don Colley has
captured the texture of the man's
clothes in different ways — straight
lines for the woolen hat, loose creases
in the pants and fingerprint smudges
to recreate the material of the jacket.

Below **Marlene Lee,**
Pete sketching, **2011.**
Often when we meet up for sketching
in Davis, CA, we sketch each other.
Here is one of many sketches Marlene
Lee did of me absorbed in sketching.
With use of hatching, and by mixing
up the tonal values, she portrays the
different textures of my hat, scarf and
jacket well.

Fast texture

Even with five-minute people sketches, there are ways to include a little bit of texture. You can try drawing the textures that you see — the silky scarf, the thick plaid shirt, the bushy beard — or by using a mixture of different-textured media. The sort of textures you find on people are not the same as you'd draw in a city street or a natural scene, but by keeping it simple, you can create various different effects.

Tips to get you started

1 **Textures on people** People are more full of different textures than you might think. Different types of clothing call for different effects; try some tight scribbling to create the effect of a woolly sweater or scarf, or light watercolor with blank patches to simulate a smooth and reflective material on a jacket. Beards and hair are fun textures to draw; curlier hair and beards are best drawn with scribbles or small lines. Don't forget the textures of unshaven faces — some simple dots scattered across the chin create an instant rough stubble!

2 **Mix up your media** If sketching in one medium, such as ink, having the occasional spot drawn in, for instance, colored pencil, will give more than the illusion of different textures. Scribbling and hatching are useful ways to suggest texture with a pen or pencil; you might want to practice different types of marks, loosen up the styles a little and use them as you need them.

3 **Use your fingers** One quick way to add some texture to your sketch is to get your finger slightly damp and brush it against some ink, then press it into the image, leaving your fingerprint. Deliberate use of this will create some interesting effects.

4 **Paper** The type of paper you use can affect the sort of textures you can create. On rough surfaces like construction paper, pencil or charcoal can highlight the coarse nature of the paper. For similar effects, try using oil pastels or crayons on watercolor paper. With thinner paper, place the page on a rough surface, such as brick or wood, and rub the pencil against it for a variety of different natural textures.

5 **Paint textures** Why not splash some dabs of watercolor onto the page? This technique creates a very textured looking appearance to the page, and colorful splotches can create a fun backdrop for darker ink sketches. Another cool effect is when you press fabric or rough material onto some wet paint; this creates a textured, clothing-like surface when it dries.

Speedy scribbling

Scribbling is fast and fun! It also gets a bad rap. You might imagine scribbling to be like the sketching equivalent of yelling into a microphone rather than singing — a sloppy, childlike habit. However, there is scope for real expressiveness with a quickly scribbled drawing, and it can be a great help in developing your sketching skills. Loosen up with some scribbling!

Tips to get you started

1 **Practice scribbling figures** Go to a public place and see how many people you can draw with quick scribbles in five minutes. Don't worry about being too accurate. Then do it again, and try to beat your "score." The faster you scribble, the looser your sketches will become, and the less time you will spend thinking.

2 **Free the lines** Worrying about being too accurate can hold you back from trying things out. Let go, and allow the lines to move about the paper as roughly as possible. Be playful, and focus on the gestures. Keep the pen on the paper, drawing in a continuous line. It may not always look much like the person you are drawing, but you will sometimes surprise yourself with what comes out when you let the line work run free.

3 **Play with gesture** Scribbling gestures can feel very liberating. If sketching someone moving their hands around, you can almost keep pace with them by scribbling. Use tools that make rapid lines. Exaggerate actions when drawing from life — capture the feeling of movement.

4 **Scribble the background** Draw a figure very quickly, but then continue the lines into the background and scribble randomly to create a dark area around the person. Make the scribbles more condensed as they get closer to the figure to help the figure stand out more. Alternatively, scribble very quick lines to represent the background objects around your people, placing them in their real environment.

5 **Different marks** Try scribbling rough, messy outlines, one on top of the other, pressing only lightly with the pencil, then adding the more defined shapes by pressing harder, but still keeping the quick scribbled line. Ballpoint pen works well for this, too. For quick shading or backgrounds, scribble short, overlapping zigzags or circular loops. They don't always need to be loose, either — tight and organized scribbles can be used to create interesting textures, such as the wool on a thick sweater.

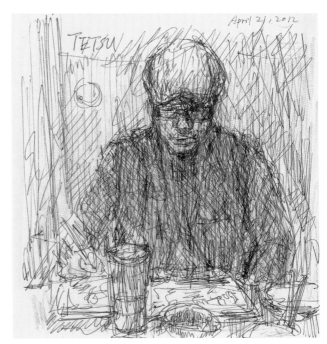

Above Pete Scully, *Man drinking*, 2016.
In this sketch, I focused on the overall shape of
the man and his pose, and let the scribbling do
all the work. If lines went in wrong directions,
a few more lines could correct that. If you avoid
taking the pen off the paper, you can allow your
sketches a bit more freedom to find their
own personality.

Above right Kumi Matsukawa, *Tetsu*, 2012.
Here, Kumi Matsukawa has used a frenetic
scribbling technique full of tight, quick hatches
and texture in black pen, with elements of
colored pencil. This was done on worldwide
sketch crawl day in Tokyo, Japan, when the
sketchers gathered later at a restaurant, and
when a little alcohol helped influence the
sketching style!

Right Marina Grechanik, *Ben Gureon*, 2015.
With very loose scribbling in a few different
colors, Marina Grechanik finds this man's
features well, and we can tell clearly that he
is not only sketching, too, but also looking up
with a smile at his subject. The loose style
complements the warm feelings in this sketch.

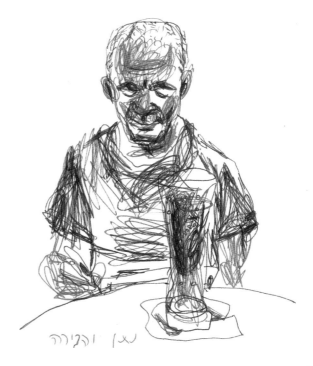

Right **Pete Scully,** *Angela on couch*,
2015.

If you are stuck for figures to draw, your
spouse or other family members seated
on the couch make for excellent targets,
such as my wife Angela, who I sketched
at home using a purple pen. I used
simple hatching for the shaded areas,
and with the gentle line work, gave this
sketch an appropriately relaxed feel.

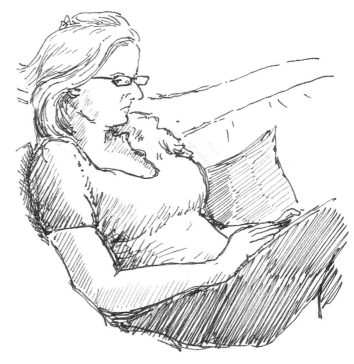

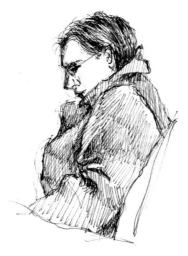

Above **Marlene Lee,** *Alan reading*, 2011.
"My husband loves to read," says
Marlene. "He becomes totally absorbed
and totally unaware of what is around
him when he is reading." In this sketch,
Marlene used quick hatching techniques
for the texture of her husband's jacket.

Right **Don Colley,** *Red Line passenger*,
2004.

Using a light gray marker, Don Colley
has used an interesting hatching
technique to show the highlights on
this fellow's face, while employing a
darker pen to create texture on the
man's jacket.

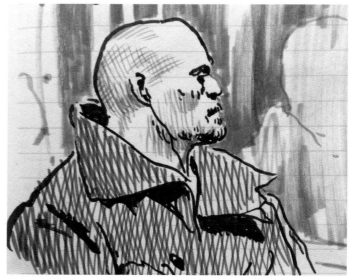

Hasty hatching

There are various ways to sketch shaded areas and create tonal effects, but when using fine pens or pencils, one of the most effective is hatching. Hatching is when you draw areas of parallel lines close together. Crosshatching is similar, but here you add extra layers of lines going in a different direction. In a five-minute sketch, hatching may seem like it would be too time-consuming, but with a bit of practice, some quick hatching can make for some amazing sketches.

Tips to get you started

1 **Simple hatching** On the area of your sketch that will be shaded, draw some quick diagonal lines, all pointing in the same direction. To make the shading darker, draw the lines slightly closer together; for less shade, draw them farther apart. The lines need not be diagonal, nor be in the same direction, but hatching like this will give a tighter feel to the sketch.

2 **Line thickness** Thin lines will take a little longer to hatch, but give you more flexibility when creating different tones. A heavier line will still make for good hatching, but will be more pronounced — try not to overdo it. If hatching with a pencil, the pressure you use will create lighter and heavier lines, which will add a new dimension to the effects. Let the hatching itself suggest the darkness of the shaded area.

3 **Crosshatching** There are a few types of crosshatching you might try. Do some simple hatching and then add another layer of hatching on top but with the lines at a 90 degree angle. Space lines closer together for darker tones. Try hatching with more than two

directions of lines, and mix it up by having the hatching go in less uniform directions. Mix it up by crosshatching in small interconnected patches, each going in different directions.

4 **Hatching on the face** When using hatching to shade the face, remember where the facial curves are and where the shaded areas will be most pronounced, such as under the eyebrows, the nose and the neck. Keep the hatching gentle, but be consistent; crosshatching in one area while hatching in another may make it look like someone is bruised rather than shaded!

5 **Hatching as a background** Hatched lines can make for a nice backdrop to your people sketches. Try adding them in a different color, perhaps one that complements the skin tone or clothes. Since it can be time-consuming, this is something you can always add later on. Hatching can be useful to suggest shadows cast by your subject.

Shade quickly

Adding in some shading to your quick people sketches gives them a much more realistic, three-dimensional feel. The way this is achieved will depend on the medium you are using, but there are some simple tricks to make the shading really effective.

Tips to get you started

1 **Identify the shaded areas** Look at the figure you are drawing and identify which areas are in the light and which are not. Don't draw the outline or the features; try drawing only the shapes of the shaded areas (easier to do if they are not moving around), showing the figure as essentially a pattern of light and shade. The shapes of facial features, such as the nose, are often defined by their shading rather than by line work.

2 **Rapid diagonal lines** When sketching in pen or pencil, a common way to depict shading is to draw thin diagonal lines over the darker areas, making them closer together in the darker spots (such as beneath the eyebrows or under the chin). Keeping this style of shading throughout the sketch will make the overall appearance feel consistent.

3 **Not too dark** Making the shaded areas too dark gives the impression that a strong, bright light is shining onto the figure; unless this is the case, tone down the shading. Even in places with strong light sources, dark areas are rarely that dark, as light reflects from many other

places. Soften the edges of the shaded areas, especially on the face, by blending them a little with the light. Subtlety with shading is key.

4 **Shading in paint** The colors you might use for shadows against buildings are not always suitable for shading on skin tones. Make them a little warmer, use a bit of purple or simply a darker version of the skin tone you're using. More effectively, since skin is reflective, leave the lit areas very pale or blank, and use normal skin tone for the shaded areas. For clothing, use less warm tones and emphasize the shadows in the folds.

5 **Casting a shadow** Shadows cast by your figure might be darker than those cast upon them, so use a darker tone or thicker hatching to create them. The edges of the shadow will often be the darkest parts, so give them defined edges. Remember that the direction of the shadow must be consistent with the shading on the person. Indoors, shadows will usually be less pronounced, unless someone is spotlit.

Watercolor wash.

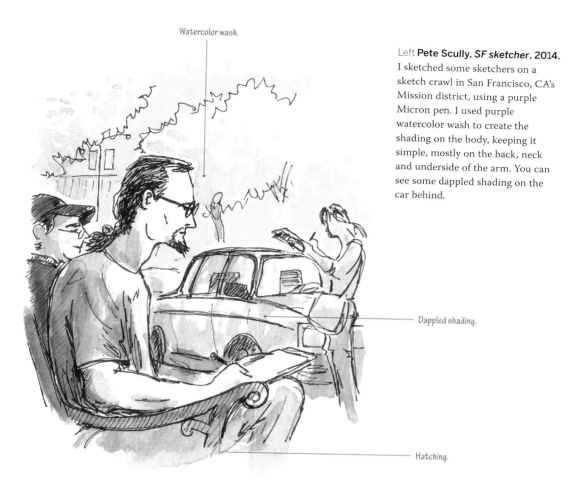

Left **Pete Scully,** *SF sketcher,* **2014.**
I sketched some sketchers on a
sketch crawl in San Francisco, CA's
Mission district, using a purple
Micron pen. I used purple
watercolor wash to create the
shading on the body, keeping it
simple, mostly on the back, neck
and underside of the arm. You can
see some dappled shading on the
car behind.

Dappled shading.

Hatching.

Right **Kumi Matsukawa,**
Luís, **2013.**

Watercolor paint is a good
medium for creating gradients of
shade, especially when the shade is
not too dark. In this sketch, Kumi
Matsukawa has painted a quick
portrait of global sketch traveler
Luís Simoes, who was visiting
Japan. Kumi has concentrated the
darker shading in the hair, eyes
and background, while the lighter
shadow of Luís's head cast upon
his white sweater is much paler.

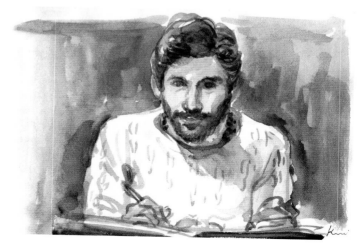

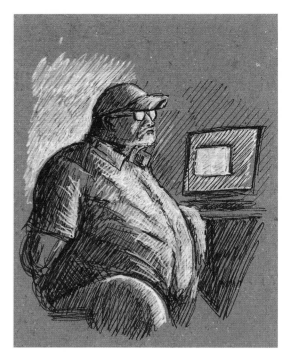

Left Pete Scully, *Tech guy at Brehm lecture*, 2010.

I sketched this tech operator in Portland, OR, while listening to architect Matthew Brehm talk about urban sketching. The room was very dark, but this guy was lit by the glow of his laptop as he operated the slideshow. I could barely see the paper as I sketched, but the white gel pen helped my own visibility.

Below Gabi Campanario, *Monochrome commuting*, 2015.

Using a digital device to sketch can often speed things up. In this sketch of an evening commute, Gabi Campanario shows us the very dark tones in order to emphasize the brighter areas, particularly the light from his digital device, which he has included in the sketch. The figure in the center of the background is in shade, while the foreground figures are well lit, with the man's white hair reflecting the most light.

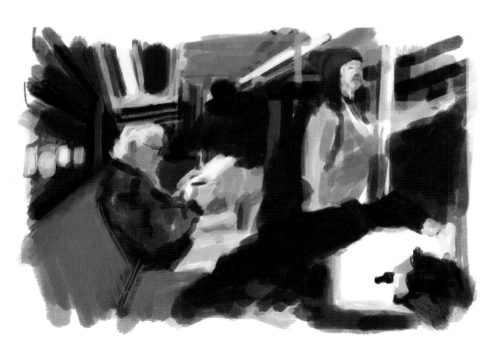

Catch the light

In a quick sketch, capturing light may not seem like the highest priority, but sometimes it can be the most attractive aspect. Whether sketching in low light or on a bright, sunny day, the illusion of light on a page can turn a flat image into a dynamic sketch.

Tips to get you started

1 **Darker shading** The simplest way to portray light on a light page is to make your shaded areas darker, particularly along the edges of the shadows; you can grade the shade to get lighter away from the edge, and this will create the illusion of bright light. Pencil does this particularly well, but pen techniques such as crosshatching and scribbling can also produce vibrant effects.

2 **See where the light hits the face** Usually this is on the cheeks, the forehead, the nose and maybe the lips, depending on the light source. Since eyes are predominantly white, they reflect light, and can contrast against the shaded area beneath the eyebrows. The shadow under the chin will often be the darkest area.

3 **Reflected light** If someone is wearing glasses, those will be a good starting point; they will be the most reflective thing and can be a way of getting around sketching those difficult eye

areas. Hair is also very reflective, so try not to sketch hair as a solid block; use your pen to pick out the darker areas and leave lit areas white or less heavily shaded. On curly hair, it can be more of a challenge, but so much more fun to sketch!

4 **Dark places** Sketching in dark spaces, such as bars or lecture rooms, provides a lot of different lighting opportunities. If adding a color wash, use warm yellows and oranges to portray a cozy atmosphere, or a light blue tint if someone is looking at a screen, such as a laptop or their handheld device.

5 **White highlights** If sketching on a colored or darker surface, use white gel pen or gouache paint to show up lit areas. Try sketching on old brown envelopes and using the white ink or paint either to highlight the occasional bright spot, or liberally to show reflection from a computer or television screen.

Simple tonal values

While we like to draw in lines, what we actually see when we look at the world are values. Tonal values can best be described as how dark or how light different areas of our drawings are. With a five-minute sketch, it may seem like there's no time to worry about this, but paying attention to values can make your sketches feel much more accomplished.

Tips to get you started

1 **Seeing the values** If drawing a person with a pencil, you might have a range of values from very dark grays, through medium grays, right down to white. The darkest parts of a portrait, for example, might be the nostrils or inside the mouth, followed by shaded areas and the eyes and hair, especially if the subject has dark hair. The different values will often blend from one to another, but the edges of your person might show a clearer boundary between values (for instance, a dark background against light skin).

2 **Practicing your values** Make marks of different shades, going from very light to very dark (or black). Try making five different values — this is called a value scale. You can get the effect by pressing harder with your pencil, or by using pencils of different weight (HB, B2, B4 and so on). Doing the same thing in pen requires techniques like scribbling or hatching, making the marks more substantial as your tonal values increase.

3 **Finding values in a group** Observe a group of people sitting or standing in one place, and quickly draw the very darkest areas. This may include the background. Then draw what look like the next darkest, then the next and so on. Be as loose and scribbly as you like; this is an exercise in seeing only the values.

4 **Shadows and highlights** The range of values you see will depend on where you are. In bright sunlight, shadows will be darker, but in a well-lit room the values will be closer. The value of a shadow cast by someone will usually be darkest at the edge. Remember that to make one area of white paper appear brighter, you need to make the shaded areas around it appear darker — that is, increase their tonal value.

5 **Values in colors** Values aren't simply confined to light and shadows. Some colors are more reflective than others, so a yellow jacket will inevitably have much lighter tonal values than a navy blue shirt. Draw someone wearing different colors, but use only black and white. Bright and dark colors like yellow and purple are easy to define, but how different are the tonal values for colors like red and green?

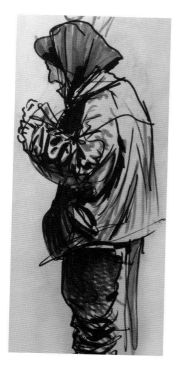

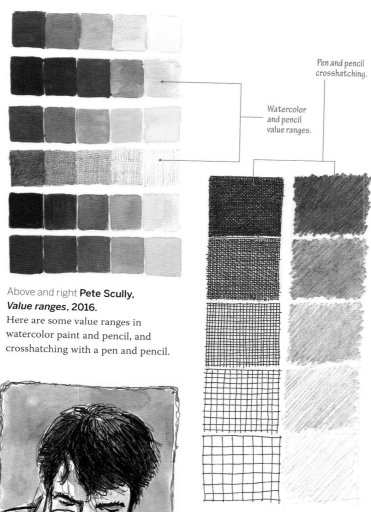

Above **Don Colley,** *Java beanhead,* **2013.**
In this sketch, Don Colley shows us a lot of contrast between the dark shaded area of this figure's front and legs, and the unshaded areas of his back, complemented by mid-tones of gray for the hood and the creases in his jacket. There are three main tonal values, but they blend together more in the pants.

Above and right **Pete Scully,** *Value ranges,* **2016.**
Here are some value ranges in watercolor paint and pencil, and crosshatching with a pen and pencil.

Pen and pencil crosshatching.

Watercolor and pencil value ranges.

Left **Pete Scully,** *Rolf Schroeter,* **2011.**
While the tonal values of the shirt and the background are almost identical, despite being different colors, the hair is a much darker value than the rest of the image, and therefore its shape stands out a lot more. The values of the hair shape do get lighter toward the top.

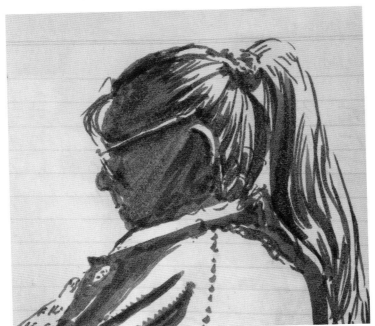

Left **Don Colley,**
On bus #151, 2004.
Don often sketches in old ledgers,
and using a marker pen he has
sketched this woman's face almost as
a silhouette, showing a clear
distinction between the shaded areas
and the light. Yet even with subtle
additions to the dark areas, you can
make out her facial features, simply
but expertly rendered.

Below **Kalina Wilson,**
NaNoDrawMo 8, 2014.
Sketching people on the bus with
marker, Kalina uses contrasting
primary colors to give the impression
of proximity – red, being the darkest,
up close and personal, with the
lighter values of blue and yellow
receding back.

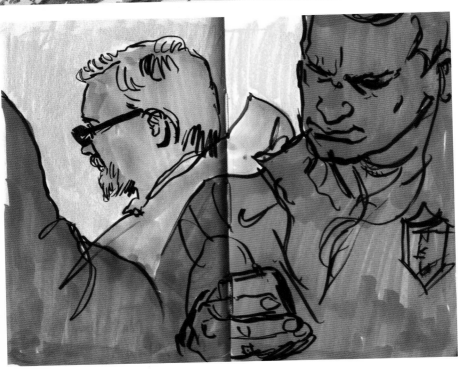

Play with contrast

As you play with values in your sketches, you might start thinking about experimenting with contrast. When we talk about contrast, we might mean two or more tones on opposing ends of the value range, such as black and white, being used against each other. But you might also try using contrasting colors, or styles, or even contrasting themes.

Tips to get you started

1 **Straight black and white** With a black marker pen and white paper, you automatically have two tones at opposing ends of the value range. With the marker, avoid drawing lines and focus purely on the shaded areas, making all darker values black and all lighter values white. This extreme tonal contrast is good practice for seeing how to construct drawings without lines.

2 **Mellow contrast** Draw a quick line sketch of a person and then shade in areas in tones of gray. Rather than using the stark black and white approach, try to find values that are slightly closer, yet still different enough apart to be in contrast against each other. For a contrasting background effect use a dark background if the person is predominantly light, or vice versa.

3 **Color opposites** You might like to try coloring in your sketches with opposing colors. Draw a person using only blue and orange, or dark brown and yellow. Try using the three primary colors — yellow, red and blue — and drawing

people solely with those. You don't have to focus just on shading; even line drawings using contrasting sets of colors can be fun.

4 **Contrasts of style** Why not mix up your styles? If sketching a group of people, you can make one become the main focus by drawing them in a tighter, more concise style, while drawing the others in a loose scribbled style, maybe using a different pen or a colored pencil.

5 **Contrasting themes** Even in a five-minute sketch, with a bit of observation you can find interesting contrasting subjects. Perhaps you are drawing two subjects who are very different, such as a fashionable lady sitting on a bus-stop bench next to a slouching, scruffy teenager. Perhaps one person is cheering, while the others around him are looking glum. Looking for contrasting themes in a sketch can lead to some interesting stories.

Sketch over color

Adding color to a quick pen or pencil sketch is often an afterthought, something to do if you still have time, like dessert. So why not eat dessert first, and start with the color? You can use paint, markers or even colored pencils. Here are a few ideas on keeping it quick!

Tips to get you started

1 **Lay wash first** When sketching a person, try starting by laying down areas of color that roughly correspond to the person's face, hair and clothes. You can be as accurate or abstract as you like, but keep it simple — focus on values and simple shapes. Then sketch the figure over the paint in more detail. Pen works best for this, although dark pencil also has a nice effect. Lines drawn over the paint tend to be sharper than when paint is added over the ink. Try not to make the wash too thick, as the paint will take longer to dry and be harder to sketch over.

2 **Prepare blocks of color** Why not color some pages of your sketchbook beforehand with blocks of color? Use some watercolor or gouache paint and fill the page, either with a thin wash or with more solid areas of paint. They don't have to be one color — mix some together for interesting gradients. Maybe try splattering watercolor over the page with your paintbrush. This will give you a set of interesting colors to sketch over in pen or marker, and you won't have to wait for them to dry. On darker paint tones, you can even use a white charcoal pencil or gel pen for highlights.

3 **Sketching over colored pencil** Because of its waxy, resistant nature, colored pencil is not always as easy to sketch over as paint, but most dark inks will do the job fine. Colored pencil has the advantage that you can scribble areas of color, and make them lighter by applying less pressure. If using watercolor pencil, only add a small amount of water to blend the wash, as overdoing it means a longer drying time.

4 **Markers** A much faster method for the quick sketcher is to use colored art markers to plot out some colored shapes, or even rapid scribbles, and then sketch over them with a finer black pen. The thick nibs on markers and bush pens will make creating colorful blocks much easier.

5 **Sketching on colored paper** If sketching on colored paper, pastels and oil pastels work very well and maintain their colors more than other media. One fun method is to cut shapes of colored paper out and stick them into your sketchbook, rather than prepare blocks of paint, and sketch on those when you are out and about.

Above and right **Pete Scully,**
***Pirates*, 2015.**

I sketched these fine pirates
at the Swashbuckler's Ball in
Portland, OR. I prepared a few
pages with blocks of colors,
and with my black pens I
sketched pirates at random.
I painted the pages while at the
event, and danced to a shanty
or two while the paint dried,
before adding the marvelously
costumed people.

Right **Kalina Wilson,**
***Swashbucklers*, 2013.**

In preparation for an evening
spent sketching pirates, Kalina
Wilson colored some pages of
her sketchbook with gouache
paint. She later sketched over
the colors with a strong black
marker and a mixture of white
and colored pencils. The overall
effect is very reminiscent of the
atmosphere at this event, the
Swashbuckler's Ball in Portland.

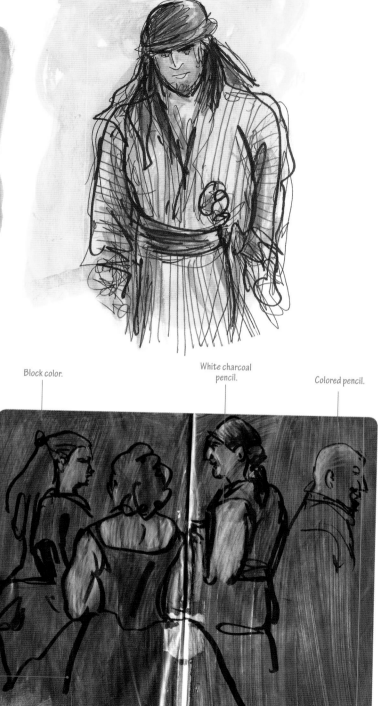

Block color.

White charcoal
pencil.

Colored pencil.

Thick nibbed
marker.

Above **Marlene Lee,**
Pete sketching, **2011.**
In this sketch, Marlene Lee uses the
colors of the redwood grove to create
a simplified background against the
dark grays of the seated figure.

Right **Kumi Matsukawa,** *Richard
and Chris*, **2014.**
Kumi Matsukawa met up with
sketching friends in Shibuya, Tokyo,
and sketched them while sheltering
from the cold in a café. Here she has
used a few muted watercolors to
create a range of soft values.

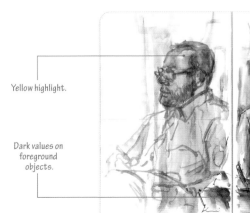

Dark green
background.

Blue
mid-tones.

Yellow highlight.

Dark values on
foreground
objects.

Quick color values

Each color affects our eyes in different ways; some naturally appear brighter and more luminescent than others. Some darker colors make good substitutes for shades, and light colors like yellow stand in for brightness. Understanding the different values of colors can really add to your sketching skill set, so get those colors out!

Tips to get you started

1 **Hue and value** The common term for colors in the spectrum (that is, excluding black, gray and white) is hue. Value measures a color's brightness, or rather how much light it reflects back to your eyes. Without checking a value chart, do a quick sketch of someone using what you think are the darker colors and what you think are the brighter.

2 **Test your color values** The best way to test the values of your colors is to take a photo of them in black and white (most digital cameras and scanners have a grayscale setting). Which colors turned out to be the darkest? The results may surprise you; while red may appear bright to your eye, its value is often lower (darker) than some shades of blue.

3 **Colors in place of values** Why not mix up your colors with those of similar value? Sketch someone using different gray values, perhaps in pencil, emphasizing the light and dark areas. Then sketch the same person again, but replacing dark grays with dark valued colors, such as navy blue, purple or red, and replace the lighter tones with yellow, cyan or light green. The results will be fun! Pastels and colored pencils are good, quick tools for this exercise.

4 **Tint and shade** It's sometimes misleading to refer to colors as simply "blue" or "green," when what you mean can be very light like sky, or very dark like navy. If using watercolor, you can create a darker shade by adding black (Payne's Gray works best with watercolor) to a hue, or a lighter tint by adding more water (mixing with white paint works, too). Make a quick tonal value range using tints and shades of the same hue. Then do a quick monochrome sketch of someone using that one color in all its values.

5 **Get the saturation right** If you use watercolors straight from the pan, you might get them at their most saturated. Adding water or gray paint can desaturate the color so they are less intense on the eye, and often more realistic — most colors you see are not in their brightest state. Be careful not to desaturate too much, or use too many colors of a similar value, as your sketch will look dull and less vibrant.

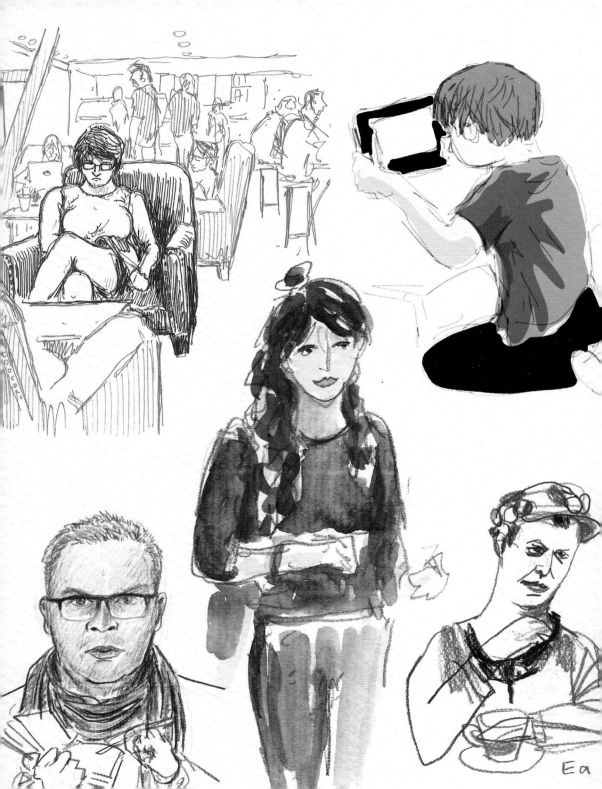

Ea

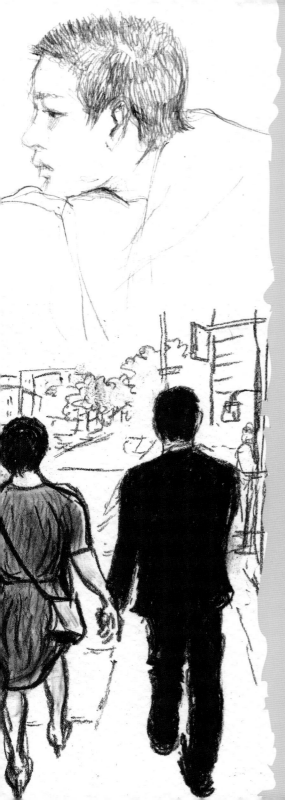

4

Speedy supplies

When you start sketching, all you really need is something to draw with and something to draw on. Choosing what those tools should be, however, is not always easy. With such a massive variety of pens, brushes, paints, sketchbooks and pencils on the market, knowing where to start can be a daunting prospect. Some pens don't work as well with certain types of paper. Some pencils won't work for your style of sketching. Even climate can affect whether watercolor paints will dry quickly or slowly — essential for a quick sketcher to consider. As with all aspects of sketching, try out different things. If that quick marker sketch didn't work, try again with a pencil or some colored pastels. Ask other artists what works for them, which pens are most reliable, which types of paper take paint. Try sketching outside the sketchbook — on paper cups, old envelopes or even drawing digitally with your electronic device.

Left Pen, pencil, charcoal, paint, even pixels — these are some examples of different materials a five-minute sketcher would use.

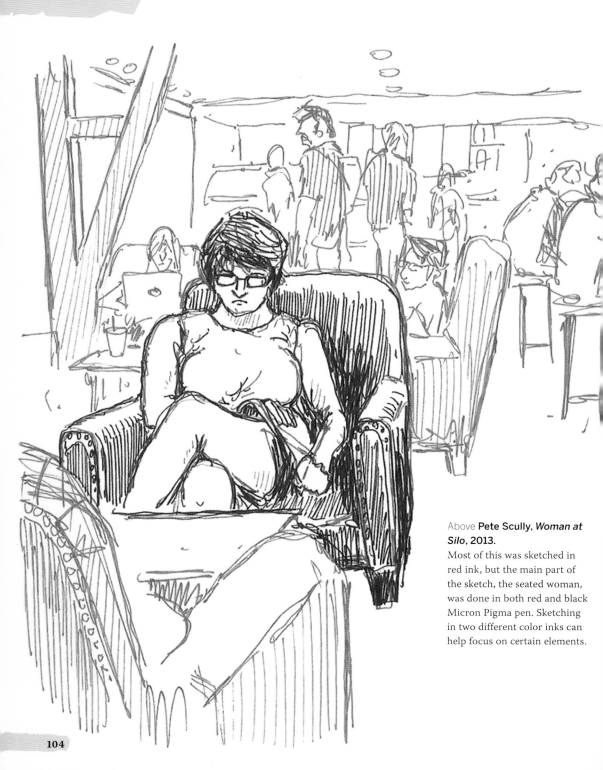

Above **Pete Scully,** *Woman at Silo*, **2013.**
Most of this was sketched in red ink, but the main part of the sketch, the seated woman, was done in both red and black Micron Pigma pen. Sketching in two different color inks can help focus on certain elements.

Quick ink

Sketching in ink is so commonplace that it's easy to forget how daunting it can be for someone starting out to decide which pen to use. Do you want water soluble or permanent ink? Do you want a fountain pen, a fiber tip marker, a fineliner, a gel pen, a dip pen, a ballpoint? Thick nibs or thin nibs? Black ink or a different color? And then there is the permanence of ink — when you sketch, there's no going back. A lot depends on the type of sketch you really want, but the best advice is to try everything and see what you like best!

Tips to get you started

1 **Common types of pen** The best pen out there is the one you are most comfortable with. Fiber-tipped pens, such as Micron or Staedtler, are popular and easy for quick sketching, coming in a range of nib sizes, but they wear down fairly quickly. Quality gel pens, such as the Uni-ball Signo UM-151, hold a very precise fine line and the nibs don't wear down. Technical pens, such as the rOtring Rapidograph, offer a great deal of precision, but can be pricey. Sometimes, though, a cheap ballpoint pen works wonders!

2 **Fountains and dips** Fountain pens have special nibs that allow for making lines of different width, and have refillable chambers inside for the ink. Many use prefilled cartridges. Try sketching with the nib upside down for an even finer line! Dip pens are similar, and have an old-fashioned feel, but rather than the ink being inside the pen, you dip it into a pot of ink to fill the nib — not always practical for the quick sketcher on the go.

3 **Keep the mistakes!** Sketching in pen means not being able to erase the lines you don't like. Rather than worrying about them, embrace them! A sketch is an organic thing and seeing the lines evolve in the sketch can give it a dimension that a more "finished" and carefully crafted piece just doesn't have.

4 **Which ink to use** Non-permanent inks will run in a wash, so if adding paint, it's best to use permanent archive inks. Micron Pigma pens work really well for this, as do certain colors in the Uni-ball Signo range, such as brown-black ink (but the black ink will run). With fountain pens, using permanent inks usually means a lot of maintenance; ink can dry and clog them up.

5 **Inky techniques** Because the shade of the line is not based on pressure, as in pencils, pen is more suited to hatching and scribbling. However, some artists like to use ink like watercolor, mixing it with water and applying it as a monochrome wash. This works best when the ink used for the lines is waterproof.

Quick pencil

There is something about sketching with pencil that feels very "pure." A no fuss, dry medium, pencil moves easily over the page and allows you to make lines lighter or darker just by adding a little pressure. For the quick sketcher, the pencil is a versatile tool, not least because you can erase lines you don't want.

Tips to get you started

1 **Types of pencil** Pencil lead (or graphite) comes in varying degrees of weight from the soft dark "B" range to the light-shaded but hard-surfaced "H" range, with the standard "HB" (or "no. 2") pencil in the middle. Pencil quality varies greatly, so use what you are most comfortable with, but watch out for cheap leads that break easily. Another option is the woodless graphite pencil, which allows for a much broader point, useful for shading. Mechanical pencils are also popular, as they keep a consistent line with no need to sharpen.

2 **Keep them sharp!** A sharp pencil point will give you a more accurate line. Having a good quality sharpener will prevent your pencil lead from breaking too often. Some people sharpen with a small knife to give a longer, thinner point, but if using a knife, always cut away from yourself. Softer leads will wear down more quickly and need sharpening more often.

3 **Erasers** Using a pencil means you erase your mistakes — or rather, the lines you don't want to keep — but be sure to get the eraser that works best. A polymer eraser can have clean results without mess. Some harder, rubber erasers are tough but can make your paper feel coarse. Kneaded erasers are soft and absorb the graphite but can get dirty. Precision erasers, built inside a pen mechanism, are handy. Sometimes, the best one is on the end of the pencil — or try not erasing at all!

4 **Line weight** While different pencil types can produce darker lines, you'll have a more consistent look to your sketch by just applying more pressure for those heavier strokes. Angle the tip to the side for a broader edge.

5 **Blending and smudging** One disadvantage of pencil is that it's sometimes easy to smudge, either with your hand or when sketchbook pages rub against each other. This is more true when using "B" pencils than "H." However, the pencil's great advantage is that you can use it to blend and create gradients of shading, especially with the "B" pencils.

Right **Marlene Lee,**
My son watching TV, 2010.
Marlene Lee likes to sketch family members
unaware, watching TV, or playing on the
computer or even sleeping. They're relaxed
and posed more naturally. Here she used pencil
sparingly to capture his pose, while using the
graphite to add detail to his hair.

Below **Pete Scully,**
Karaoke singer, 2016.
I was at a bar in Santa Barbara, CA, where they
had a karaoke night, and so I sketched as many
of the singers as I could in the short time
during each song. In this one, I used pencil
and kept it loose. I added some pale gray
marker to blend details together.

Below right **Gabi Campanario,** *Frank
Bettendorf*, 2010.
Seattle, WA-based urban sketcher Gabi
Campanario drew fellow sketcher Frank
Bettendorf on the bus in pencil, using the
pencil to create a variety of different values.
Pencil works quickly, even for a detailed sketch.
Gabi included elements of the background
to show the natural perspective lines.

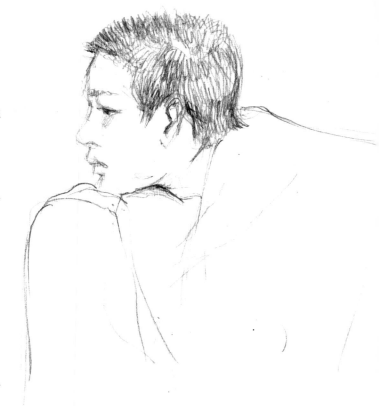

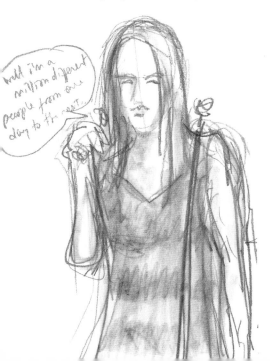

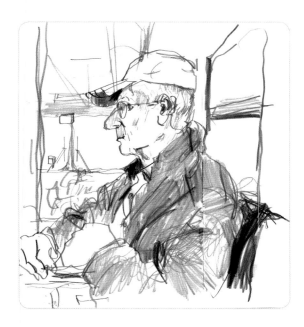

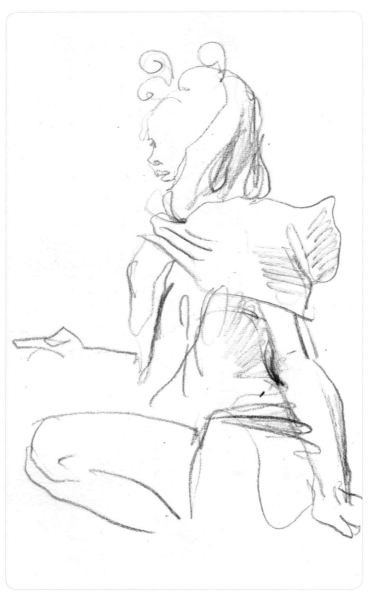

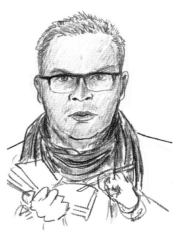

Above **Pete Scully**, *Selfie 36*, 2016.
In this selfie, in which I wore my
favorite scarf, I used a black colored
pencil to sketch the general outline
and details, adding heavier pencil
marks for the scarf, with several
warm colors more softly added for
the face and hair.

Left **Kalina Wilson**, *Dark fairy*, 2013.
Portland, OR, artist Kalina Wilson
used a special colored pencil to
sketch this "dark fairy," a model at a
drawing event called Dr. Sketchy's.
The pencil's lead is multicolored, so
you can change the color of your line
at a stroke, creating a technicolor
effect even in a simple line sketch
such as this. Such pencils save time
and yet make for beautiful drawings.

Quick colored pencils

Sketching in colored pencil is not quite like sketching in regular pencil. The range of colors allow for more tonal variety, and they are easier tools for creating texture. Although the rich feel of a colored pencil drawing may take practice to do in a five-minute sketch, colored pencils are very user friendly, and they are a lot drier than paints and inks — and the colors definitely won't run if it starts raining!

Tips to get you started

1 **Which ones to get** Some people carry a few basic colors with them, while others will carry as many as a hundred pencils, all in different colors — and it can get expensive! For the on-the-go sketcher, a smaller set of 10 or 20 is all you really need, available in easy-to-carry tins. Some colored pencils are waxy, others are oil-based and a bit harder. Brands like Faber-Castell, Prismacolor and Derwent offer better quality pencils. Don't forget a sharpener!

2 **Watercolor pencil** Water-soluble pencils are usually a little softer and work in the same way as dry colored pencils, but when water is added with a brush they will act just like watercolor paint, and can be blended together in interesting ways.

3 **Add a little pressure** As with pencil, pressing lightly against the paper will produce gentler, more muted colors, while adding more pressure will produce much bolder colors and lines. Use the edge of the pencil tip to create gradients of color — very useful when coloring in hair or

clothing, or when adding a quick background. Be careful not to press so hard that you snap the point! Dropping the pencil will also break the lead inside so be careful of that.

4 **Draw fast and bold** For quick and bold results, use thick outlines, scribble uneven blocks of color within, and let the colors overlap each other. Unlike paint, the colors will not run, but some colored pencils will not draw over others. Try using the pencils like children's crayons; be playful, experiment.

5 **Use in mixed media** If sketching in pen or with watercolor, adding a few areas in colored pencil will provide a different flavor. Colored pencil's big advantage over watercolor is that if using a nonpermanent ink, it will not cause the ink to bleed into the colors. For fast sketching, use scribbling within lines to suggest color, especially if the subject is moving around.

Quick markers

Art markers are an increasingly popular tool for the sketcher, and it's not hard to see why — they are easy to use, quick to dry, and come in an exciting range of colors and tones. Whether sketching in bright color or monochrome, the marker pen can create vibrant sketches in minutes — but they are hard to correct, often bulky to carry when you have more than a few and they can get quite expensive.

Tips to get you started

1 **Types of marker** There are lots of different markers you can choose. Tombow dual markers are water-based, long and thin with a brush nib on one end and a narrow nib on the other. Copic sketch markers are much thicker pens, alcohol-based with both wedge-shaped and brush nibs. Prismacolors are popular with professionals, are similarly double-ended and come in a wide range of colors, while Pitt markers by Faber-Castell come in nibs from very fine to "big brush." Sharpies are also good for drawing, though tend to bleed through the page more.

2 **Easy marker tips** Try drawing the contours of a person with a darker pen, in a thin or thick nib, keeping the features to a simple minimum. Then with a lighter toned brush marker, add in the shading, putting more layers in the hair and beneath the eyes and nose. Markers make the shading easier to imply. Waterproof markers also combine well with a watercolor wash. They dry quickly, so you don't have to worry about them bleeding into the paint.

3 **Blending in** You can create nice blends with certain markers, going over each layer to make a color darker or more pronounced. This can dirty the nibs; clean them by rubbing them on a different page. Try using a colorless blender marker to smooth out colors and soften edges.

4 **Best paper to use** With most media the paper has more subtle effects on the outcome, but with art markers it's a good idea to know ahead of time whether they will bleed through the page and onto your other sketches. Often it depends on the pen. Thick, smooth paper such as Bristol works well, and there are special pads created especially for drawing in marker pen.

5 **Mixing up your markers** Many people stick to one brand when drawing in markers; each brand uses different ingredients that don't always work well with other brands. However, if only carrying a few markers with you, a heavy pen like a Copic can sometimes complement a lighter, more fluid pen such as a Tombow. Play around to see which pens work best for you!

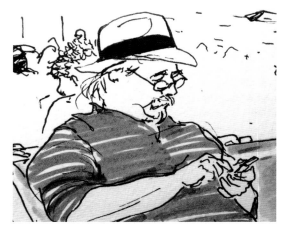

Left **Don Colley,** *Fred at Penn Station,* **2013.**
While much of the sketch is done with a finer tipped black marker pen in a precise manner, deftly capturing the man's relaxed expression, Don has shaded the shirt with a wider tipped gray marker in a looser style. The thick black band on the hat stands out against the gentle gray.

Below **Pete Scully,** *David Devant at the 100 Club,* **2010.**
I sketched my favorite band at the legendary 100 Club on Oxford Street, London, England. I sketched the background quickly in a thin pen and then the band once they came out using a brush pen. Their features are reduced to gestures, and the onlookers simple shapes.

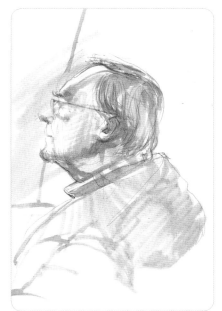

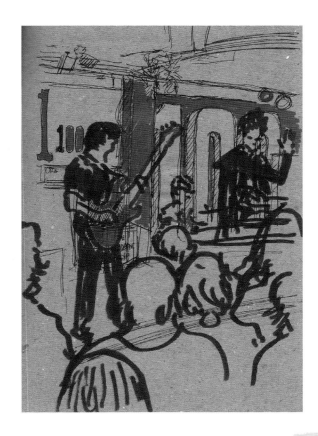

Above **Adebanji Alade,** *Commuter,* **2014.**
London sketcher Adebanji Alade sketched this man on the Number 11 bus using a brown pen, and used a warm gray marker for the quick shading. The combination of the thick gray marks with the fine brown lines gives a gentle effect.

Below **Kumi Matsukawa,**
In the train, 2012.
Kumi sketched her friend from
Canada, along with some other
sketching friends, on this train back
from Kamakura, Japan, primarily
using a light blue watercolor. Where
another sketcher might use a pen,
Kumi used a brush, drawing the lines
directly in watercolor to great effect.

Right **Pete Scully,** *Woman in Davis,*
CA, **2016.**
Sketching the shoppers at the Davis,
CA, Farmer's Market is a good way to
spend a Saturday morning. People
move just slow enough to capture
them on paper, stopping at stalls to
check things out. I sketched this
woman first with a few pencil marks,
then added the paint using a
waterbrush, all in just a few minutes.

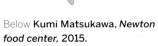

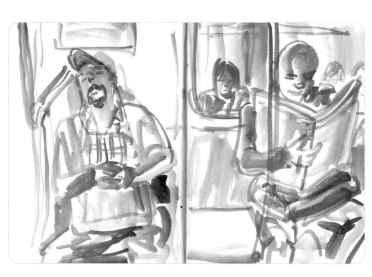

Below **Kumi Matsukawa,** *Newton*
food center, **2015.**
The line work in this sketch by Kumi
Matsukawa is made directly with the
watercolor paint. The warm flesh
tones complement the purple, and
the background is rendered lightly
using watered-down versions of the
same colors.

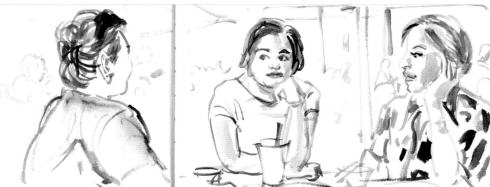

Quick paint

For the five-minute sketcher, painting might seem like a lot of extra effort. However, a small, handheld watercolor set is easy to carry and can really liven up your sketches. Adding a wash of color can give ink or pencil sketches an extra dimension, but why not try sketching directly with the paint? Watercolor is most convenient for the urban sketcher, but thicker, bolder paints like gouache can make your sketches pop.

Tips to get you started

1 **Get a handy paint kit** A small, travel-sized set of watercolors is ideal for the fast sketcher. Those that can be held in the same hand as a sketchbook are even better. Small sets often mean a limited number of color options, and you can get really creative with just a few basic colors, but don't feel like you have to limit your palette to save space; if you can, add as many colors into your little set as you can fit!

2 **Basic brushes** Choosing the right brush can be daunting, so stick with a basic 3 or 4 round size for fast, small sketches. Larger brushes can speed up painting bigger areas, and smaller fine-tipped brushes suit more detailed sketching. To really save time, try using a water brush, prefilled with clean water — especially useful when you are sketching in a tight space and have nowhere to put your water.

3 **Paint the line** Don't be afraid to draw outlines using paint, as you would with a brush pen. Use different colors for your outline — perhaps brighter colors such as pink or turquoise — and

if adding a background, paint them in different colors again. Experimenting is the best way to find out what color combinations you like best.

4 **Dim your colors** Bright colors are visually stunning, but sometimes they can feel a little unrealistic and distracting. Try mixing your paints so they aren't so saturated — add more water, maybe some Payne's Gray or ultramarine. For skin tones, practice mixing colors for a variety of tones that you can call back on when sketching people.

5 **Don't overwork it** The beauty of sketching directly in paint is that it can appear effortless. Technique takes practice, but using as few strokes as possible and not overdoing it will give the best effect. Besides, the more paint you add, the longer it will take to dry — and for the five-minute sketcher, time is everything!

Quick pastels and charcoal

Compared to quicker, cleaner media such as pens, sketching in pastel or in charcoal may appear to be an unnecessarily messy business, more suited to hours in the studio than moments on the go. However, pastels are easy to carry, inexpensive and can create incredibly colorful sketches in moments.

Tips to get you started

1 **Sketching in pastel** Pastel's big advantage over paint is that it is already dry when you put it on the page. Pastels are usually fairly soft, and while they create nice lines they also lend themselves well to creating quick textures, either by rubbing the edge of the pastel against the paper or by scribbling, hatching and blending. However, they are not the same as chalk, which is usually much harder and a lot less vibrant. They can get dusty, though — watch the mess on your clothes!

2 **Draw fast in oil** Oil pastels are cheap and a little like crayons, but are usually softer and waxier with brilliant, bright colors. They are easy to use, almost like doing a quick sketch in oil paint, and you can still blend them.

3 **Try different papers** Pastel works really well sketched on either grayscale or colored paper. Unlike with watercolor, white or light colored pastels stand out against the colored background. Slightly toothy construction paper is good for rougher pastel techniques. Or why not try sketching on thin newspaper? Be careful not to press too hard, or you'll tear the page!

4 **Choose charcoal** Charcoal may be the oldest drawing medium that exists; it was probably used by cavemen. It is still popular today as a simple and inexpensive tool for the sketcher on the go, although it is easy to smudge. When used on rough paper it can give interesting textures, but charcoal is best used for its expressive strokes, and can create brilliant, deep blacks.

5 **Keep it clean** With pastel and charcoal, you usually need to have a good "fixer" to stop the medium from smudging into a mess on your sketchpad. Art stores usually stock small fixing sprays you can carry with you. Oil pastels don't usually need fixing, but they will make opposing pages sticky, so a scrap of tracing paper usually helps protect the sketches.

Below **Marina Grechanik,** *Ea and Reza*, 2015.

In these sketches, Marina Grechanik has used colored pastel economically to create lively line sketches of Danish artist Ea Ejersbo and her husband Reza. Even with a thicker medium such as this, Marina has been able to create details that tell a lot of story.

Ea

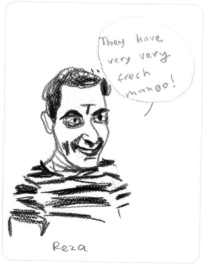

They have very very fresh mango!

Reza

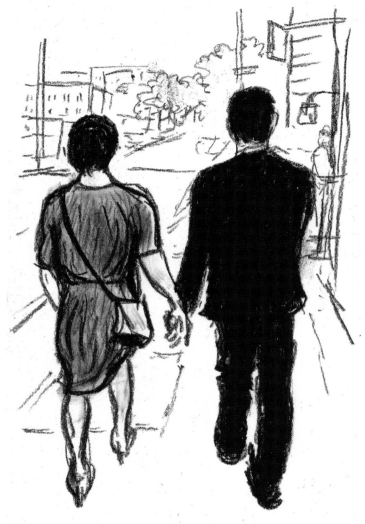

Above **Pete Scully,** *Figures walking*, 2016.

Charcoal is messier than pencil or pen, but can produce some stunning blacks. It smudges easily, which I used here to produce the gray tone in the woman's dress. I added a few lines of background, but kept them loose to bring out the bold shapes of the figures.

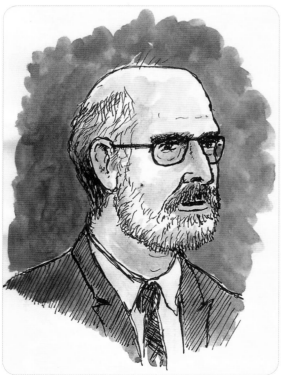

Above **Pete Scully,**
George Roussas, 2013.
Professor Roussas is a well-known
Distinguished Professor Emeritus of
Statistics and a member of the
department where I work, and I drew
him at our annual holiday party while he
was talking to undergraduates. The
sketch itself took a few minutes, but I
added the wash afterward. I used very
warm skin tones to show off his jovial
features, with the light blue background
serving to bring out that warmth, and
also because Professor Roussas is
from Greece.

Left **Pete Scully,** *Dean Gibeling*, 2014.
Jeff Gibeling, the Dean of Graduate
Studies at University of California, Davis,
has been sketched here with reasonably
tight lines in a small portrait and then
colored in afterward. While the lines are
sometimes overlapped, they are compact
and feel a bit more measured for closer
accuracy.

Sketch first, color later

You don't need to be a painter to use a bit of paint. Carrying a small watercolor set that you can pull out and use quickly is a good way to add an extra dimension to your pen or pencil sketches, with only a few strokes of the brush. Even if you don't have time to add paint on the spot, you can always come back and add it in later.

Tips to get you started

1 **Keep it simple** It is a good idea to keep the wash fairly light. It is very easy to overdo it and let the paint overwhelm the ink sketch, but with watercolor there is always the feeling you must "get it right first time," so try to keep it simple. Also, lighter washes tend to dry more quickly — helpful if you're in a hurry! Mix your colors in the palette before laying them onto the paper.

2 **Precision and looseness** If a person is sitting or standing in one place, more "precise" coloring-in can add to the static effect, while if a person is moving about, the reverse can be true — being looser with the paint strokes can give the impression of movement and energy. Of course, in a quick sketch you may not have time to be too precise; practice will give you the skills to determine how much color is needed.

3 **Check the ink** Be sure if adding watercolor to a pen sketch that the ink is waterproof, otherwise the lines will blur and muddy the paint. While this sometimes can be a desirable effect, more often than not it produces unpredictable results and makes your line work dull.

4 **Warm skin** Skin tones vary, but as with real skin it's best to stay warm. For lighter skin tones, try mixing a little orange or yellow in with a pale red wash, aiming for more "peach" than "pink," while with darker skin tones, add brown to red for a more "cinnamon" tone. Remember that skin reflects light, especially on the face, so allow for light or white patches on the forehead, cheeks and nose.

5 **Reference** If you don't have time to add color on site, you can always make some notes or even take a quick picture with your phone or device to use as reference. Try not to let photo references distract you, though — the light will always be different from what your eyes saw. Sometimes when sketching people on the go, they are just that — on the go. More often than not, you'll be adding color from memory, and if it's not quite right, nobody will notice!

Play with paper

When we spend so long thinking about what to draw with, we often overlook what to draw on. There are probably as many types of paper as there are tools, and choosing the right one can mean a lot of experimentation. The paper that works best with your favorite pen may take watercolor badly; one pen will bleed through the page but not another — it will take a lot of trial and error to get things the way you like them.

Tips to get you started

1 **Popular sketchbooks** There are so many sketchbooks on the market, the most popular brand probably being Moleskine. Try choosing a sketchbook that will give you support when you sketch on the go — a hardback cover works best — and consider whether a spiral-bound book might be easier to hold if sketching in a tight spot. In spiral-bound books, the pages are looser, so pencil sketches in particular are more easily smudged.

2 **Smooth drawing paper** Many types of drawing paper are fine for pens and pencils, but often buckle quickly if a watercolor wash is added. Thicker paper, such as bristol board, is perfect for most inks, while for art markers, special, super thin paper is available which is coated to prevent bleeding through. Smooth paper that is traditionally meant for writing can be excellent for drawing — use lined or squared paper, or even old ledger books, as urban sketchers Lapin and Don Colley do, to great effect.

3 **Watercolor papers** Watercolor comes in cold press — usually rougher and textured — and hot press, which is usually smoother, but not quite like cartridge paper. Thicker paper will take the paint well, but may slow your pens down. Some fine-line pens will have their nibs worn down by watercolor paper. Watercolor paints can appear brighter on paper made especially for them.

4 **Other surfaces** Drawing paper need not be smooth and white. Toned paper has always been popular with artists, especially for pencil sketches, and gray or brown paper is good when you want to include white gel pen lines or gouache. Colored construction paper may be better for craft projects than sketching, but combined with pastels gives wonderful results.

5 **Play around!** Why not cut up some different types of paper — smooth sheets, construction paper, even old brown envelopes — and bind them together into a self-made sketchbook? There are many ways of making your own custom books, such as glue-binding, saddle-stitching and the trusty, old long-armed stapler.

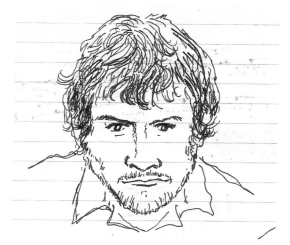

This is my nephew Anthony, also
an artist, sketched quickly on the
thin-ruled paper of a Moleskine
diary. It is good for quick
sketches, though you can see a
sketch from the other page
seeping through.

Watercolor.

Cheap brown
paper.

White gel pen
highlights.

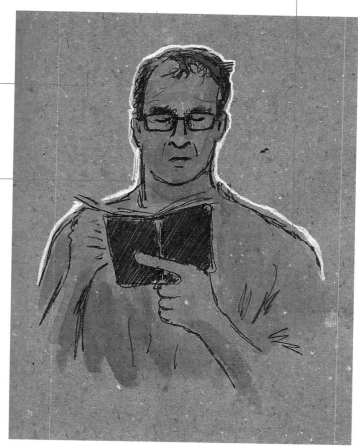

Right **Pete Scully,**
Gabi Campanario, 2010.
I sketched Gabi, founder of Urban
Sketchers, at the first Urban
Sketching Symposium in Portland,
OR. That year I was obsessed with a
small handmade sketchbook filled
with cheap brown paper, and I used it
to capture many of my fellow
sketchers. The brown paper was
handy for using the white gel pen as a
highlight. Here, Gabi is sketching me
right back.

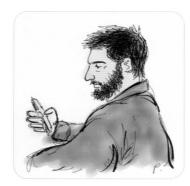

Left **Pete Scully,**
***Man with phone*, 2016.**
In this sketch, I used a slightly
thicker fountain pen tool to add
more substance to the figure's
contours. I laid down the basic
color shapes first with the brush
tool, before drawing over them
with the black pen tool.

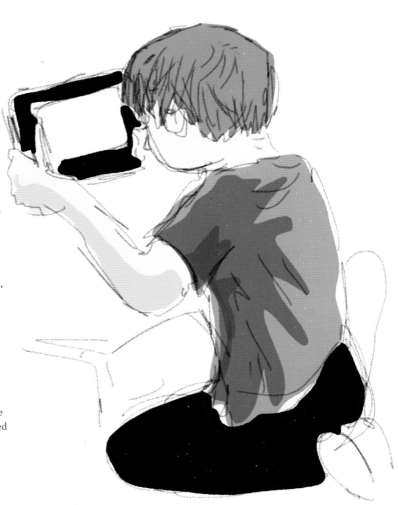

Above **Gabi Campanario, *Woman
with big bag*, 2015.**
Rather than sketch in lines, Gabi
Campanario has used areas of
digital color to compose this lady
seated on a bus. Additional colors,
such as green and yellow, serve to
highlight the light on her face.

Right **Pete Scully, *Luke playing
video games*, 2016.**
Using the Paper app on my tablet
I sketched my son Luke playing
a game on his Wii U, crouched
against our sofa. I drew his outline
with the pencil tool and then added
color as individual shape blocks.
It's fairly minimal and takes only
a couple of minutes, but this
approach is pretty effective.

Go digital for speed

So many of us now have touchscreen digital devices — whether it's a cellphone, an iPad or some other tablet device — that the natural next step is to use them as a sketchbook! There are a lot of apps out there now for on-the-go sketching. With digital sketching, you can be as quick as you like; you don't need to remember your materials, and when sketching people, you can be a lot more inconspicuous — you're just another person looking at their screen!

Tips to get you started

1 **Quick apps** There are many sketching apps available; try a few out for ease and usability. Some give the effect of real watercolor paper, and even free apps offer a lot of tools and effects, usually as add-ons. Paper by FiftyThree is a popular app for the iPad, while you can get more technical with an app like Procreate, which has realistic watercolor effects.

2 **Stylus or finger?** When you first start sketching with your touchscreen device, it might be with your finger. This can get nice, organic-feeling results, but is a little imprecise. A stylus brings back the feeling of using a pen or pencil. Styluses can be either hard-tipped or rubber-tipped, but the technology is updating all the time, so upgrade when you can. Getting a good quality stylus will make a lot of difference.

3 **Digital sketching technique** So what's the best way to sketch digitally? As with "analog" sketching, this is up to you, but it's worth practicing a few different ways first before settling. Using a pencil tool to block out your subject is not a bad idea; then you can go over it with a bolder pen or brush tool. Try sketching with a light colored line on a dark background; use the technology to achieve things not always possible with your usual tools.

4 **Digital painting** The best thing about digital painting is that you don't have to wait for the colors to dry, so you can dive right back in. The sort of effects you can get depend largely on the app you use, so check that it is optimal for paint effects. You can paint digitally in ways not possible with a portable watercolor set — you can layer down the dark colors first and then build on top of them, as you might do with oil or acrylic (not usually suitable for five-minute sketches). And there's a handy "undo" button!

5 **Practice!** Sketching with a digital device may be quick at first, but as with any other medium you aren't used to, it's not necessarily easy. Some programs have a range of different tools to practice with, but the ease of digital sketching means you can practice as often as you like!

Sketch off page

The avid sketcher always carries a sketchbook — but you don't always need one. Having the finest paper money can buy doesn't mean you'll get great sketches, so try experimenting and sketching "off page." Wherever you are, there is usually something you can draw on — as long as you're allowed to!

Tips to get you started

1 **Sketching at the table** Get a group of urban sketchers together for a meal and they will draw on anything made of paper — napkins, placemats, menus (if they're the disposable type!). Restaurants with paper tablecloths are a sketcher's dream, though the waiters may feel bad about throwing them away afterward! Napkins are more difficult, but you can get good napkin sketches with the right pen (a cheap ball-point works well). If at a bar, try sketching a series of sketches on the back of beer coasters; if they get a little damp from the drinks, it only adds to the sketch. Plus, you can give them away to people you meet!

2 **Envelopes** Rather than throwing out those old envelopes that come with the bills, keep them and use them for sketching! Often the interior of the envelope will have an interesting printed pattern, and if there is a little window, try to use that in your sketch somehow. Brown envelopes make for great sketches, and if you order a lot online, sketch on those brown delivery boxes!

3 **Books, maps, newspapers** Newsprint is thin and disposable, and can give your sketches a feel of real time and place if sketching over news stories. Some artists like to sketch over the text in old books; if traveling in a different country, buy an old book from that land and try sketching local people in it. Similarly, sketching on maps locates your sketches geographically. If sketching someone on a black and white street map, try coloring in the streets afterward as a background to your figure.

4 **Plastic** If you have some clear acetate, such as is used with overhead projectors, this can be a fun material to draw on if you have the right sort of colored acetate marker. Many pens won't stick to it, and you won't be able to paint on it! It can be fun to hold them up and let the world around you act as a real background. Sketching on the inside of plastic grocery bags is tricky, but not impossible — a good Sharpie marker should do the trick.

5 **Fabric** You could sketch on fabric — old T-shirts, tea towels or just bits of old material. A fabric marker might be needed, and it isn't a particularly quick way to sketch, but if you cut up all your fabric sketches of people and sew them together later, it might make a nice quilt.

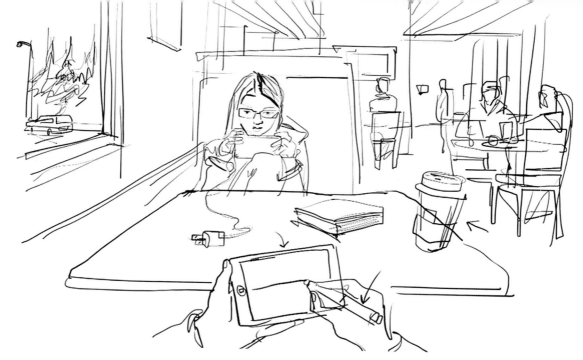

Above **Gabi Campanario,**
Sketching at a table, **2015.**
Here Gabi used a tablet, a Wacom
Intuos Creative Stylus and the app
Procreate make this quick sketch at a
café. As well as the seated pose of a girl
engrossed in her own digital device,
this sketch serves as a good example of
basic perspective.

Right **Pete Scully,** *Drakes*
beermat, **2016.**
This was sketched quickly onto a beer
coaster while cooling down in Davis,
CA, after a day spent sketching in the
hot sun. I liked the unusual shape of
this coaster, and used black ink and
white gel pen to sketch this couple.

Key elements

These pages will provide you with a few starting points for common people elements such as facial features, poses, and typical body proportions. Why not make your own "cheat sheet" of common features to refer to when you're sketching? Having these to fall back on will really speed up your sketches!

Practice basic features

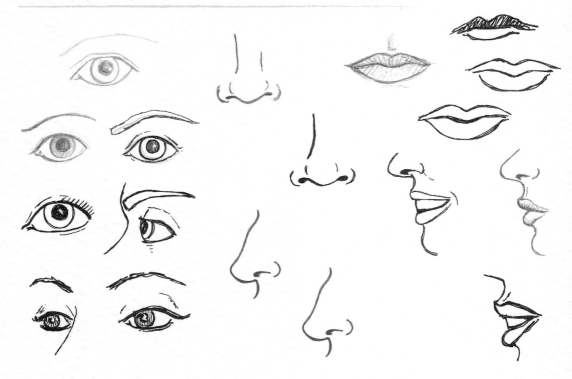

Eyes

Here are some eyes to give an example of their general shape. In a quick sketch of a person, you may only have time for a few key elements, such as a circle for the pupil and a line above it, plus the eyebrow. Avoid drawing too many lines, as these can age your subject.

Noses

Noses are tricky, but the key is keeping lines to a minimum, especially drawing head-on. With the nose in profile, take care to watch the angle it sticks out at.

Mouths

Mouths come in many sizes and have the greatest variance of expression, but these show the basic elements. In a quick sketch, when including teeth, minimal to no detail is better; just keep it simple.

Figures in common poses

Figures

Here are some examples of figures in various poses. It is useful to have a few typical poses to use when out sketching public scenes.

Female figures

Female figures are broader in the hips than the abdomen.

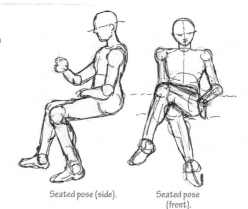

Seated pose (side).　　Seated pose (front).

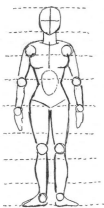

Female figure proportions.

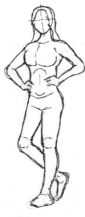

Female casual pose (leg bent).

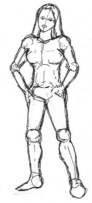

Female casual pose.

Heads

These examples of heads show the most basic composition. Female faces tend to be narrower toward the chin.

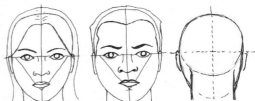

Male figures

Male figures are broader around the shoulders.

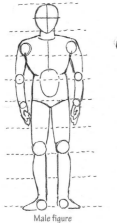

Male figure proportions.

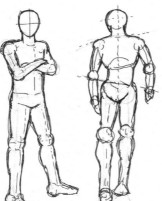

Male casual pose.　　Rear walking pose.

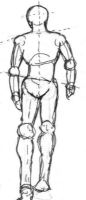

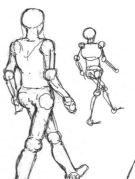

Side/rear walking pose.

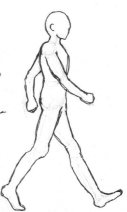

Side walking pose.

Index

Acknowledgments

Author Acknowledgments

I would like to thank my wonderful wife Angela for her endless patience while I wrote this book over many late nights and weekend afternoons. Thank you also to my awesome son Luke, who made sure I took much-needed breaks from the laptop to play video games and Lego and soccer with him. I'd also like to thank the creative staff at RotoVision, particularly Nick and Abbie and Alison, for their efforts in making this book happen from a different time zone — I am very grateful for your patience!

Thanks go to all those artists who contributed images for this book, and to all those fellow urban sketchers who have taught me so much over the years, and gave me the confidence to start sketching people in the first place.

Thank you to my colleagues at the University of California, Davis Statistics Department, who have always encouraged me. To my family back in London, who let me draw all the time as a kid (and as an adult), thank you for everything. And finally, a second big thank you to Angela for being so supportive of my life as an artist. You're the best!

Pete Scully,
Davis, California
petescully.com
flickr.com/photos/petescully

Artist Credits

Adebanji Alade, 111
adebanjialade.co.uk
adebanjialade.blogspot.com

Gabi Campanario, 27, 45, 92, 107, 120, 123
gcampanario.com
flickr.com/photos/baconvelocity

Don Colley, 66, 84, 88, 95, 96
buttnekkiddoodles.com

Cathy Gatland, 14, 31, 58, 77, 78, 80
asketchintime.blogspot.com

Marina Grechanik, 54, 57, 77, 87, 115
marinagrechanik.blogspot.com
flickr.com/photos/marin71

James Hobbs, 37
james-hobbs.co.uk
Marlene Lee, 34, 53, 70, 75, 84, 88, 100, 107
marleneleeart.com
flickr.com/photos/calliartist

Kumi Matsukawa, 7, 22, 49, 50, 61, 87, 91, 100, 112
flickr.com/photos/macchann

Rolf Schroeter, 17, 45, 46, 53
skizzenblog.rolfschroeter.com
flickr.com/photos/rolfschroeter

Patrizia Torres, 37, 42, 65, 69
www.flickr.com/photos/patxarantorres

Kalina Wilson, 17, 39, 66, 96, 99, 108
geminica.com
flickr.com/photos/geminica

Samantha Zaza, 18
szaza.com